Officially Osbourne

OPENING THE DOORS TO THE LAND OF OZ

THE OSBOURNES WITH TODD GOLD

SIMON &
SCHUSTER

books

EDITORS: Jacob Hoye and Lauren McKenna

ART DIRECTION/DESIGN: Gabriel Kuo, Andrew Kuo / theBRM

COVER PHOTO: Gregg Delman

PHOTO EDITOR: Walter Einenkel

RIGHTS AND CLEARANCES: Andrea Glanz and Michelle Gurney

PHOTO CREDITS:

Amy V. Cooper: 1, 3, 18, 21, 22-23, 25, 42-43, 44, 46-47, 50-61, 63, 100-01, 102, 104, 106-07, 140-45.

Michael Yarrish: 2, 12-13, 15, 16-17, 24, 27, 31, 33, 34-35, 37, 45, 48-49, 76, 86-87, 110, 112-13, 114, 152.

Gregg Delman: iv, vi, 19, 28, 69.

Chris Ameruosa: Pet portraits on 103.

The Tonight Show with Jay Leno image courtesy of NBC Studios.

First published in Great Britain by Simon & Schuster UK Ltd, 2002
A Viacom Company

1 3 5 7 9 10 8 6 4 2

Simon & Schuster UK Ltd
Africa House
64-78 Kingsway
London WC2B 6AH

www.simonsays.co.uk

Simon & Schuster Australia
Sydney

A CIP catalogue record for this book is available from the British Library

Trade Paperback ISBN 0 7432 3968 7

Printed and bound in Great Britain by
Butler & Tanner, Frome

Acknowledgments

We want to thank so many people, starting with all of our fans for being so kind to us and for letting us into their homes; President George W. Bush for being so nice to us (and even knowing Ozzy's name); Colin and Mette Newman, our friends who are a major part of the Osbourne family (our lives would not be the same without them); Tommy Mottola, for believing in us; Michele Anthony for always being there; Steve Barnett, Polly Anthony; Rod MacSween and Marsha Vlasic; Michael Guarracino; also to Rod Aissa (the first one to believe in us), Greg Johnston, Lois Curren, and Van Toffler; Jeff Stilton; Lisa Vega (kisses); Dan Strone; thank you to Ari Emanuel and Brian Lipson; and of course we want to thank every one of our animals for being so cute and cuddly and loving. (A special thanks from Sharon to Aimee for being the subbornest and most loving person; and my other darling, loving babies, Kelly and Jack; and my wonderful, loving husband, Ozzy; and all of the people out there sending love and prayers. I hear you and send the same love back to you.)

—THE OSBOURNES

This book was a group effort made possible by the Osbournes, Lisa Vega, Beth Gold, Abby Gold, Eliza Gold, and Jeremy Gold; also Evan Cooper, Dan Strone, Sara Roby, Carolyn Reidy, Louise Burke, Liate Stehlik and Lauren McKenna. Thank you.

—TODD GOLD

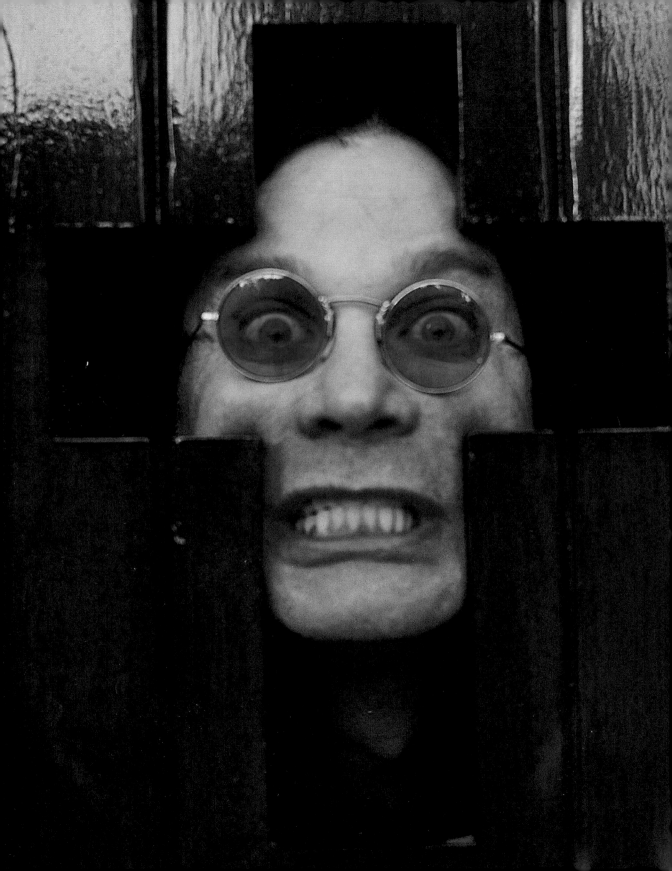

Officially Osbourne

Contents

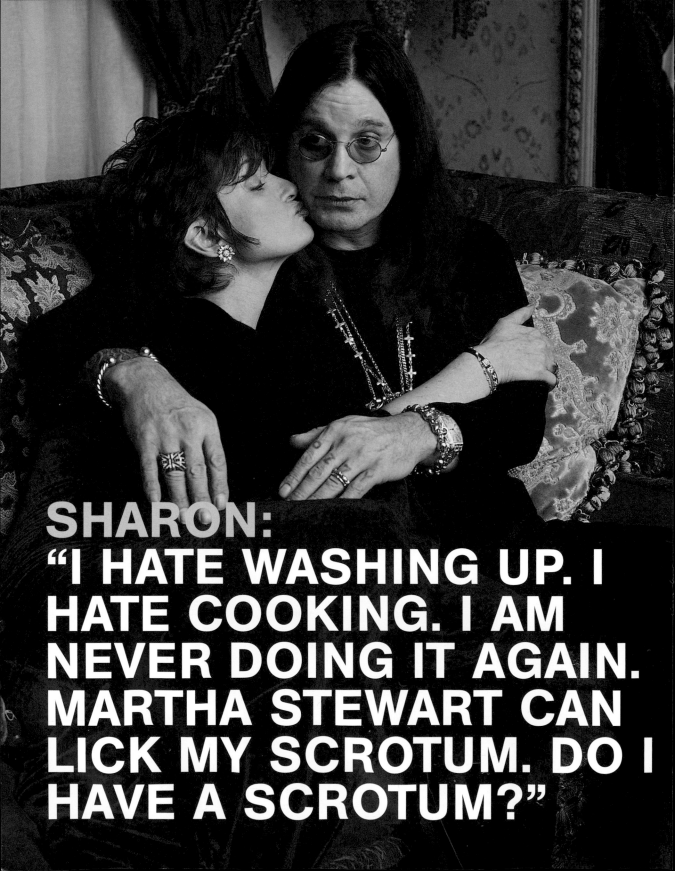

Introduction

JACK:

How do you describe this thing that happened to us?

KELLY:

Are you asking me?

JACK:

No, it's a question I'm asking and then going to answer myself.

KELLY:

Good, because I don't #$&*ing care. I don't even #$&*ing get it.

JACK:

I'm talking, okay? It's like Mom and Dad said the cameras could go here and there.

KELLY:

I thought it was another one of their crazy ideas, and I just said okay.

JACK:

I said I'm talking.

KELLY:

Excuse me.

JACK:

I never thought about when it would air or what it would be like. It's normal life to us.

KELLY:

Maybe people like it because we're not that different and we're not full of #$&*. But I don't understand it, to be totally honest. Nor am I about to waste any time thinking about it.

JACK:

To me, it's like a home video. Fortunately, it made a good show. I think people can relate to things that happen.

Everyone thinks you have this grand lifestyle, with champagne, water fountains, gold-plated bathtubs, and other #$&*. Then they realize that Dad and Mom and all of us are a regular family, and they relate to our issues.

KELLY:

I didn't think anyone would watch it. To be perfectly honest, I don't think it's that interesting. I mean it's my life.

JACK:

It's very weird.

KELLY:

My life?

JACK:

No, the whole thing—the show, the success, the way people have reacted.

KELLY:

Yes, very weird.

JACK:

Which, when you think about it, is kind of normal for us.

KELLY:

You know what I like about it?

JACK:

What?

KELLY:

I wasn't actually asking you. But you just like to hear yourself talk.

JACK:

Shut up, Kelly.

KELLY:

What I like about it is the way we love each other. We really do.

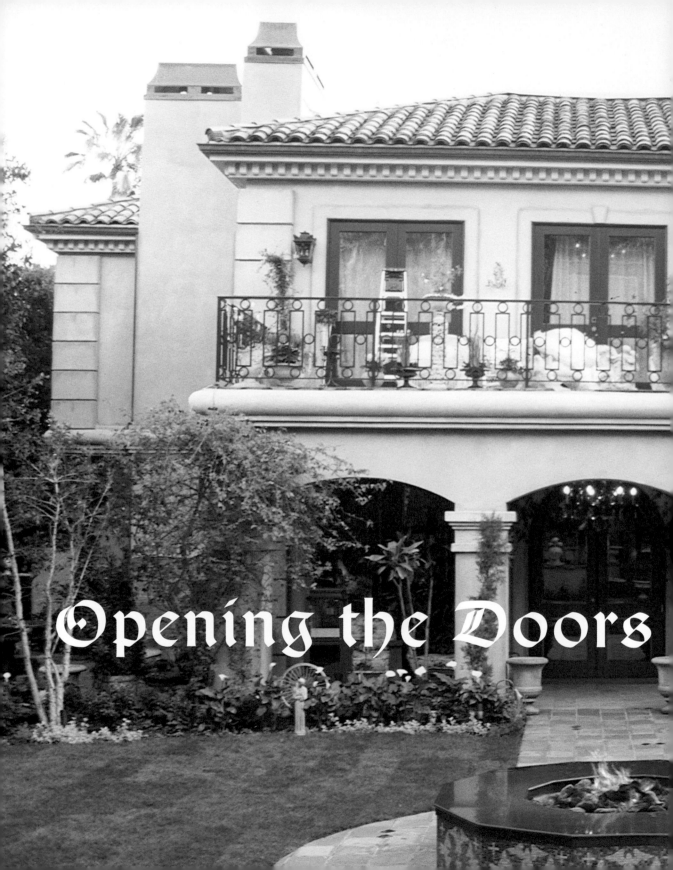

Opening the Doors

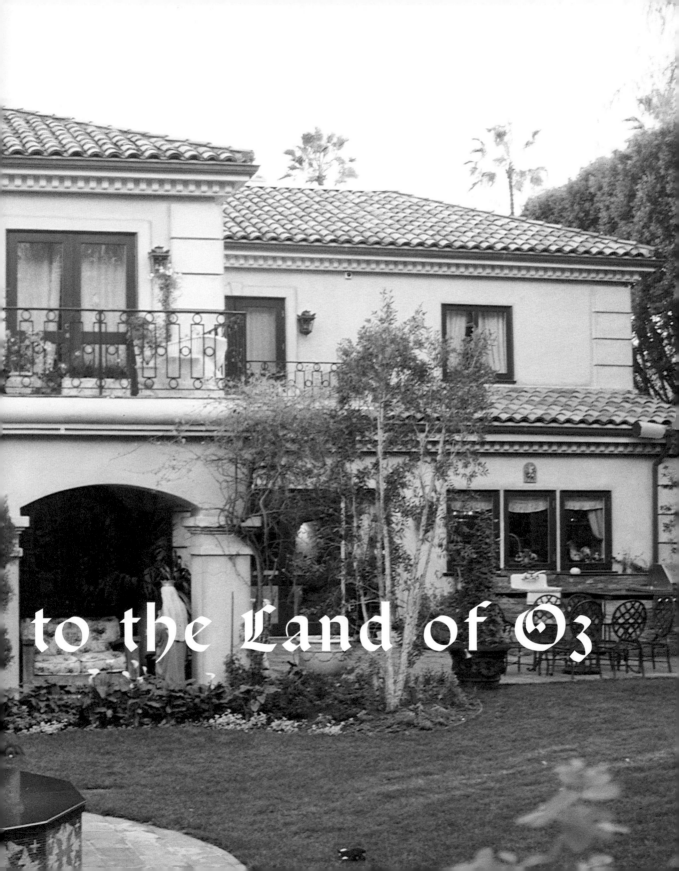

to the Land of Oz

"If I'd had any idea the show was going to do so well, I would've asked for more money," says Sharon Osbourne, giggling. "None of us had any idea it was going to work."

Don't believe her—entirely. "I pitched the same idea to Fox about six or seven years ago," she admits. "I always thought Ozzy was very funny, and I thought it would be unique if a celebrity opened their life up to cameras. But Fox never even called me back."

"Hey, if there's one thing people in rock and roll know, it's that when Sharon Osbourne talks, you pay attention. Sharon is the family leader," says Ozzy. "She's the brains of the operation. And she knew television needed a dose of heavy mettle. She knew MTV would get her idea."

Cut to the Ivy at the Shore in March 2001. Sharon, Aimee, Kelly and Jack are having dinner with a bunch of MTV executives. Sharon has been thinking that her kids would make good VJs on TV. Ideas are exchanged. Everyone is laughing at the stories she tells about her twenty-year marriage to her bat-biting heavy metal icon husband and their methods of raising children.

"There was a Christmas party," she says. "I got smashed. The girls put me to bed. When I woke up, I had a flower in my butt."

Laughter.

"People won't believe this stuff," she continued. "I tell them what it's like in our house and they never believe me."

"I can understand why," one of the executives said.

"I don't see the big deal," Sharon said. "My husband is an alcoholic. I'm a shopaholic. We've got a kid who smokes funny cigarettes. Our daughter has pink hair. This is our life."

Afterward, the MTV executives agreed that if the Osbournes were half as entertaining as Sharon's stories, they would have a great show. At a second meeting, executive producer Greg Johnston suggested "coming over with cameras."

Sequence: **HUGS AND KISSES**

THE PARTICIPANTS:

"Let's just see what happens," he said.

MTV had produced many innovative and edgy shows but never one built around the f-word—family. But they thought they had a winner; Sharon agreed. "We're moving into a new home," she said. "Wouldn't that be a great way to start?"

A few weeks later Johnston showed up for a preliminary meeting. All of a sudden Ozzy ran out of the house and came face to face with the producer.

"Who the #$&* are you?" he asked. It was the first time they had met. "I'm Greg Johnston from MTV," he said. "Huh?" Ozzy asked.

Then Sharon came running out after her husband. "Sing that song for me," she demanded. She turned to Johnston and explained, "I'm trying to get him to sing this song that's my favorite." Too late. Ozzy jumped in a car and left.

The next meeting went better. It was in the upstairs of the Osbourne's new Beverly Hills mansion. It was a war zone of workmen hammering and sawing. Sharon sat on the floor of her's and Ozzy's bedroom. She was conducting the first production meeting for *The Osbournes* with Johnston and supervising producer Jonathan "JT" Taylor.

"If we're going to do this, it's all or nothing," she explained.

Welcome to life at chez Osbourne. As Sharon stroked her favorite dog, Minnie the Pomeranian, Kelly and Jack wandered in and out. Aimee also passed through. As they discussed the details, expectations, and mechanics of letting camera crews past their front door and breaking down every sacred boundary of family life, the producers worried that Sharon seemed distracted. "There were so many things going on, people coming in and out, I really didn't know whether she was absorbing what we were saying," recalls JT.

The original agreement was for three weeks of shooting, then a pilot, and if all went well, perhaps there would be more taping. It seemed easy to Sharon, and yet it scared the hell out of those in charge. "I thought, Wow, this is going to be very tough, much tougher than *Road Rules*," says JT. "On a show like *Road Rules*, you have control of the cast. You own them.

"But in this situation, we were going to be living in someone's home. It wasn't a set, it was their house. It wasn't a group of kids we'd auditioned, this was a family. And not just *any* family. It was Ozzy's family. They could kick us out at any time. It was either going to be hell or a lot of fun."

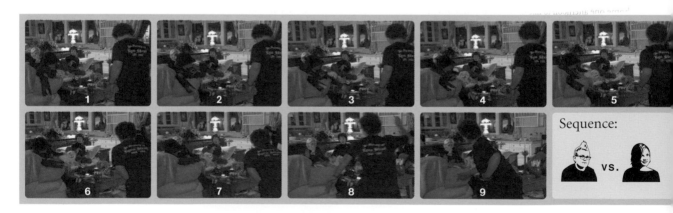

Sequence:
Ozzy vs. Kelly

What did the Osbournes think? "I didn't have any $%#$ing idea," says Ozzy. Sharon discussed it with everyone, including Melinda Varga and Gloria Lopez, the family's nanny and cook, respectively, and except for Aimee, who didn't want to be on the show, Sharon says, "Everyone else agreed to jump in. We went feet first."

Still, MTV's producers kept asking for a meeting to make sure the family was on board, especially Ozzy, whom they still hadn't met even as shooting was about to begin. "We thought it would be a good idea if we talked to him," says JT. But every time they mentioned such a meeting to Sharon, she would smile and say, "Don't worry. It'll be fine."

And so it was. Cameras were set up in every room of their house, a downstairs bedroom was turned into a control room, and three camera crews basically took up residence. The Osbournes' lives would become public domain. Soon practically the entire world would be discussing Ozzy's inability to work the TV remote, Sharon's spiritually inspired shopping sprees ("The Virgin Mary speaks to me. She says you must go to Tiffany. And on the way, stop at Cartier"),

Jack's aversion to camp, Kelly's trip to the gynecologist ("the vagina doctor"), and Lola's uninhibited habit of doing you-know-what on the expensive carpet.

On October 8, 2002, the MTV crew—a total of about thirty people alternately coming and going—moved into the house and began taping Ozzy, Sharon, the kids, and everyone else who ventured into their daily and especially their nightly activities. "It was awkward at first," says Melinda. "I always cringe when I see the first episode because none of us were used to the cameras. I felt like a robot. But we eventually got so used to it the crew felt like other people hanging out."

Not since the Clampetts of the classic TV series *The Beverly Hillbillies* had such a unique family settled in the hills of Beverly. Not since the Louds on PBS's landmark series *An American Family* had a family been so willing to share their lives. The only ground rules? "Me taking a $#@@," says Ozzy, "and my bedroom." (Behind the scenes fact #1: Before shooting began, technicians tried to install cameras in Ozzy and Sharon's bedroom, but Ozzy nixed that idea. "I needed a little #$&*ing privacy," he says. Nevertheless, they put one in Kelly's sitting room and watched Jack around the clock.)

What about the Osbournes' oldest child, Aimee? There were high hopes she would change her mind. In fact, Sharon thought she could persuade her firstborn to go with the family flow. But Aimee made her position perfectly clear by moving out of the house. "I don't care what my mother told you," she informed MTV's producers. "I'm not going to be part of this."

"Aimee's such a fantastic person, and she's got so many other things going on in her life, and she's so amazing and so mature and so wise for her age," says Melinda.

JT says, "She's the lady in the family. Aimee is Marilyn on the old TV series *The Munsters*. She's the normal one. It's hilarious. You have this family of lunatics and then all of a sudden there's Aimee, who looks at her parents and siblings and goes, 'You guys are all crazy. I don't know how I got here, but I'm not supposed to be in this family.' "

"I think she's full of crap," says Kelly, "but who cares."

"Aimee knew being on the show wasn't for her," adds Melinda.

Ozzy had a moment where he felt the same about himself. It was about two weeks into the pilot, and Ozzy was having a nightmare. Actually, he was wide awake—and that was the problem. Stressed from the preparations for his tour, he came home one afternoon to find it filled with workmen, decorators, and the usual assortment of crazies treating his home as their home. On top of all that, he had a camera pointed at him.

It was all simply too much for a heavy-metal god in need of quiet time, and he quickly disappeared into his private sanctuary, a screening room that was declared off-limits to the MTV cameramen. When Ozzy shut the door, no one went in. During these early days, he frequently hid out in there. "I love you all," he explained on more than one occasion. "I really mean it. But you're all #$&*ing mad!"

A few nights later, Ozzy appeared to have reached his breaking point. Following a few frustrating encounters with the cameras during moments when he wanted his privacy, he sat down on the front steps of his house and buried his weary head in his hands. The cameramen backed off. Sharon sat down beside him. It was, according to supervising producer JT, "a really private moment. Sharon was consoling him."

"It's going to be okay, Daddy," she said. "It's going to work out."

She was right. Ozzy came into his own the night Kelly confessed she had gotten a tattoo. "[Mommy's] not mad," he said to his daughter. "She's just very disappointed. She thinks you're a very stupid person."

The crew was laughing uncontrollably, and soon Ozzy was advising JT to keep a camera pointed at him all the time. To their credit, none of the Osbournes minded the cameras. "I wasn't self-conscious," says Kelly. "I didn't care. I didn't worry about how I looked or anything. I was simply, whatever. People see you how they want to see you, not how you really are."

Early on, the MTV crew had a harder time establishing boundaries than did the Osbournes. They were downright frightened by the first big fight they witnessed between Jack and Kelly. "It was a monster," JT says. "It got physical. We didn't know whether to shut down or keep rolling or take cover."

SHARON:
"DON'T WORRY. IT'LL BE FINE."

In any other household, such an outburst between siblings would be something to keep hidden from the neighborhood, never mind a camera crew. Only with the Osbournes could it be considered creative magic, the kind of spontaneous moment that made the whole family thoroughly giddy about their show—that is, until they found out the cameras had been turned off by the uncertain crew. Indeed, when the crew came the next morning, a disappointed Jack and Kelly asked, "Why'd you stop rolling?"

They wouldn't make that mistake again. But then time ran out—or so it seemed. The three weeks originally allotted for shooting ended. Although no one had mentioned a specific date that the crew would pack up and leave, Jack finally broached the subject with the supervising producer. "So you guys are out of here, right?" he asked.

Wrong. Earlier, an MTV exec had stopped by the house, looked at some of the footage, and quickly struck a new agreement with Sharon to continue shooting for an unspecified amount of time—long enough to get ten episodes.

The experiment worked out better than anyone had anticipated. About five weeks into production, in early November, Ozzy asked JT what he thought about the footage they had gotten. "Truthfully, I think it's some of the funniest, most entertaining television ever made," he said. "I'm totally serious." Melinda got the same reaction from another producer. "One day I asked what the show was going to be like," she recalls. "He said, 'We think it's going to be great, humongous, as big as *Friends*.'"

The reason? "Ozzy's sense of humor," says Sharon. "I think he's so funny."

"I don't try to be that way," says Ozzy. "To be frank, I don't see what's so funny. I honestly haven't got a #$&*ing clue. But people think I'm hysterical."

Beyond. The crew laughed all the time but never harder than one day when Sharon took the kids out and left the crew with Ozzy. It was so early into the production they really didn't know how to handle Ozzy on his own. "Bye-bye, darling," Sharon had chirped to JT. "He's in your hands now."

"After they were all gone, I was like, 'What'd she mean?'" recalls JT, who went back into the control room and quickly had a situation on his hands. "Ozzy was in the kitchen and I heard this singing," he says. "I looked at the screen, and he was in a jovial mood. He was singing. Then he was talking directly to the security cameras we'd installed to monitor the different rooms. It was like he was talking to us. Those of us in the control room looked at one another and said, 'This is weird. He's really in a weird mood.'

"Well, before leaving, Sharon had hidden several bottles of wine, and Ozzy, who was on the wagon, had found them. I can't say how quickly that happened, but it must have been within moments, because barely any time passed between when she left and when he started to sing.

"Soon it was pandemonium. Ozzy started singing songs from his album, and he wanted the crew to come into the kitchen and hang out with him. It was wild. It got to the point where he was going to keel over, he was so drunk. The camera and sound guys were escorting him all over the house. Finally, we put him to bed. Then Sharon came back, and she had a big, knowing smirk on her face. I was like, 'How could you do that to me?'"

Thanksgiving was another fiasco. "Ozzy had had a few glasses, and it just got totally out of control," JT says. "After a few drinks, Ozzy wanted to go walk the dog. Then he started arguing, and soon they were all arguing. It got to the point where halfway through the day I sent the crew back home."

The others had their own moments. Jack really didn't want the cameras following him to school, and he hated it when they caught his mom kissing him good-bye. Kelly tried keeping the cameras out of her bedroom and bathroom, but she wasn't always successful. "It was so #$&*ing annoying," she says. On the other hand, she didn't let producers bully her into doing something she absolutely didn't want to do, such as taking her father to a Britney Spears concert. "I'm not going to see #$&*ing Britney Spears!" she screamed. "You guys better get that straight. It's never going to happen."

"Well, I don't think it's such a bad idea," Ozzy said.

"That's only because you want to see her boobies, Dad," she said. For all the shouting and fighting, there was much more

OZZY:
"I JUST COULDN'T THINK ABOUT IT. WHEN I DID, IT MADE ME SICK."

laughter and love. Take Christmas, which started out in the afternoon with Ozzy carving a turkey amid a lavish spread of holiday food in the kitchen. Without warning, Sharon summoned the entire crew—everyone, including the producers and directors who normally kept to themselves in the control room. "Get in the kitchen—now!" she said.

"What's up?" JT asked.

"This," she and Ozzy said, nodding toward the platters of smoked salmon, caviar, meats, and champagne, "is for all of you guys. Merry Christmas." The gesture sparked an outpouring of affection from all involved as they sat around the table and traded stories of past holidays. Sharon made sure this one would be memorable. "Somehow she had managed to get a gift for almost everyone," JT says. "It was amazing."

About a week later, Sharon was given a tape of the first episode. "She'd been dying to see something, and we kept delaying and delaying because we didn't want them to see themselves while we were taping," JT says. "Then one day she got her hands on a rough cut. I was so paranoid because I didn't want them

talking about themselves rather than living their story.

"But Sharon promised me that she would be the only one to watch it. Fine. Then the next afternoon I went into Jack's room, and he had something like fifteen of his friends there, with popcorn, and they were all watching the tape.

"Then Ozzy saw it, and he hated it. Though he's seen himself on music videos and onstage, seeing himself completely revealed at home was a big shock. He was very upset. Which was the whole reason I didn't want anyone to see the tape. But a day passed, all of them moved on to different things, and it was forgotten."

"I just couldn't think about it," says Ozzy. "When I did, it made me sick."

That had no bearing on Sharon's decision to end the first season, which she did with the same authority she had exercised at the start. On January 30, 2002, she called JT into her sitting room. "Jonathan, I need my life back," she said.

"That was it," he adds. "It was over. Right then and there we ended production."

Episode Guide #1:
There Goes the Neighborhood

"Crazy, hey, but that's how it goes"—at least that's how the lyrics to the opening theme song of *The Osbournes* go.

And from day one, move-in day, life with the Osbournes reveals itself to be just that—crazy. Amid the chaos of furniture movers, roaming pets, and wardrobe boxes filled with devil heads and "dead things" appears a family of true rock and rollers: wife, mom, and commander in chief of family affairs, Sharon Osbourne; retro-alternative-cool son, Jack; pink mop-topped daughter, Kelly; and husband, father, and rock star extraordinaire, Ozzy Osbourne. Oh, and not to be ignored—although she often is by Jack—the family's young Australian "nanny," Melinda.

Sequence #1:
MOVING IN

It is a scene not entirely unfamiliar to most families who have moved. The Osbournes simply have more stuff.

While Sharon directs the crew of workmen and marvels at the family's overabundance of decorative crucifixes, Ozzy fools around with the dogs, and Jack and Kelly chase each other through rooms that look as if they've been hit by a hurricane. Not only are the family possessions strewn about in every direction, but the family itself is content to quarrel up a storm. (Sharon is pissed that almost every possession that is unpacked has been broken; Melinda endures abuse from Jack when he tells her to "get a real job!")

As for Ozzy, he basically spends his time trying to figure out how the hell to function in his new Beverly Hills mansion. The rock star is completely overwhelmed with the technology of his new digs. He can't get the television to work, and the ringing of his cell phone baffles him. "I turn on this one button and the shower goes on! What the hell is this . . . where am I, man? And the nightmare continues! Nightmare in Beverly Hills!"

START°

Sequence #2: REMOTE CONTROL

The family drama continues, even once they leave the confines of their home. Ozzy boldly performs a song (from his first solo album in six years, *Down to Earth*) on *The Tonight Show with Jay Leno* while his manager and wife, Sharon, coaches and calms him on the set. Jack and Kelly party on the Sunset Strip; plus, Kelly rips on Jack for using his status as Ozzy's son to get into clubs, leading Sharon to say, "Well, I'm Ozzy Osbourne's wife. Now shut the #$&* up and go to bed!"

At home, the Osbournes are protected by security guard Michael Clark, whose duties range from patrolling the perimeter to playing pool with Ozzy and Jack to hanging out in the kitchen with Sharon.

Finally, Ozzy describes Kelly and her daily "wobblers," or freak-outs, to the camera. The sixteen-year-old goes ballistic in the kitchen after starting a fire on the stove. She is further agitated when Ozzy contributes—in a most fatherly way—by singing "Burning Down the House"!

Sequence #3:
FATHER KNOWS BEST pt.1

THE PARTICIPANTS:

Sequence #4:
FATHER KNOWS BEST pt.2

THE PARTICIPANTS:

OZZY
"I LOVE YOU. I LOVE YOU ALL, BUT YOU'RE ALL ING MAD."

Sequence #5: SNOGGING

THE PARTICIPANTS:

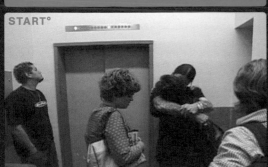

START°

1

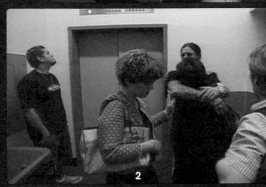

2

3

4

BEST LINES

† **Ozzy** (on the Weather Channel):
"The weather in Afghanistan—
2000 degrees and cloudy."

† **Ozzy's advice to Kelly and Jack before they hit the clubs:**
"Don't drink and don't do drugs, and if you're going to have sex, use a condom." *(Sequence #3)*

† **Kelly:** Why don't you listen to me?!!
Everyone else hears what we said!
Ozzy: Let me explain something to you . . . you have not been standing in front of thirty thousand decibels for thirty-five years! Write me a note!

† **Ozzy:** "I love you. I love you all, but you're all #$&* mad." *(Sequence #4)*

HIGHLIGHTS

† Ozzy trying to work the television remote control

† Michael, the security guard—
doing everything but securing the house

† Ozzy, Kelly, and a fire in the kitchen—
"the first one in the new house!"

BAD WORD BOX SCORE

32 12
13 9

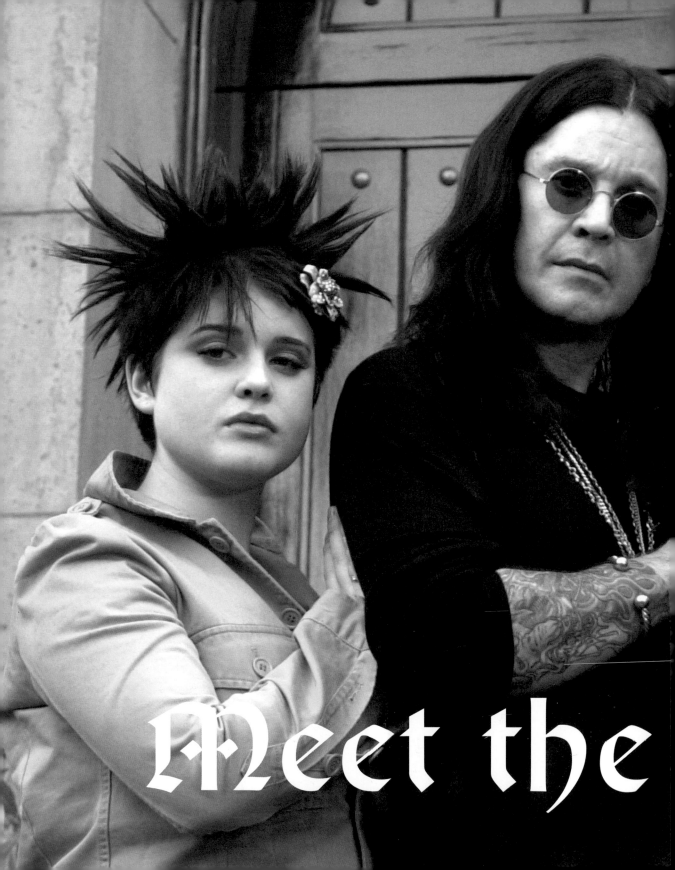

Meet the

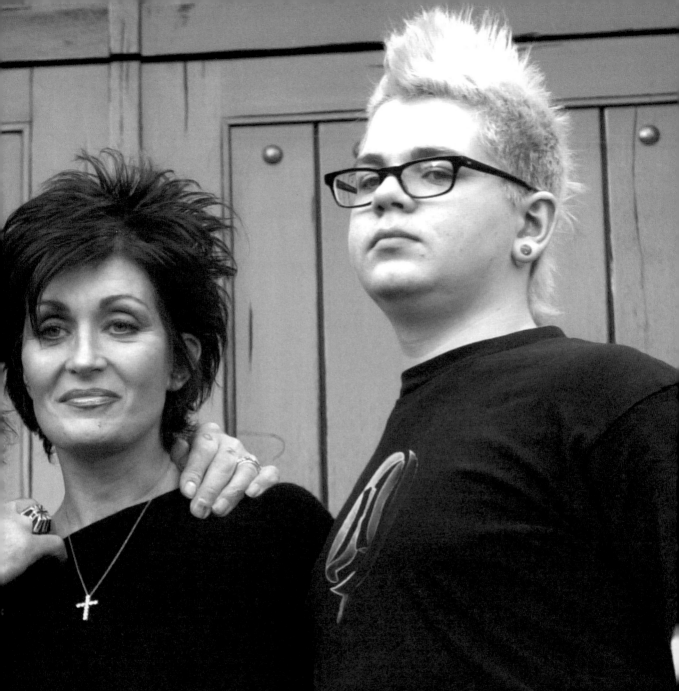

Osbournes

Jack

JACK'S PROFILE

By the time Jack threw a fit about having to go on a school camping trip, he was just like any other fifteen-year-old who wanted to sleep late—and in his own bed. "Studies show a teenager's brain doesn't really become functional until past ten-thirty," he said. Undeterred by glasses or zits, he is a powerful force, cool, with the confidence to declare, "I'm an ass-kicking fat kid."

JACK OSBOURNE

BORN:
November 8, 1985/Scorpio (Virgo moon and strong Libra/ Sagittarius influence)

RULING CARD:
Queen of Clubs

FAVORITE BANDS:
Tool, Incubus, Faith No More, System of a Down, Tenacious D, Rage Against the Machine, Slipknot, Mudvayne

VIDEO GAMES HE PLAYED MOST ON SHOW:
"Half-Life," "Team Fortress"

PHILOSOPHY:
"Waking up in a pool of your own spit and a bed covered in your own urine—it's fun."

ABOUT *THE OSBOURNES*:
"To me, it just looks like a home video. It's nothing more than that."

OZZY ON JACK:
"Jack's a very good boy . . . sometimes. Compared to me, he's an angel. At Jack's age, I was drinking massive amounts of booze, smoking pot, doing speed."

JT ON JACK:
"He was the trooper of the family. He's hilarious. He went into this experience saying, 'Okay, whatever, I'm here, I'm a good sport, do whatever.' He got it. You could always get Jack to do what you wanted him to do."

Indeed, he's not typical. "He's brilliant," says Melinda. "He's so ambitious, talented, together. I swear he'll be running a record company by the time he's twenty-five."

He's on his way. By sixteen, Jack was already working as a scout for Epic Records. He was instrumental in getting his family on MTV's *Cribs*. He helps select bands for his father's successful Ozzfest summer tour. Next is his own record label. "Jack lives for music," says Sharon proudly. "That's his main ambition. He just wants to get this record label up and going."

"Jack's very, very mellow and a pretty cool guy," says Sharon, who expects him to be a big success in the music biz. "Jack has good hair. For real development, you've got to have someone with good hair in the record company."

WHAT IS YOUR FAVORITE CD OF ALL TIME?
My favorite CD would have to be Tool's *Aenima*. It's such an amazing album. I've been listening to it for about two years now, it's solid.

WHAT ARE YOU LISTENING TO NOW?
I listen to a lot of early Incubus. Faith No More, Ghouls, Tomahawk, System of a Down, Tenacious D, Slipknot, Mudvayne, Rage Against the Machine.

WHAT WAS YOUR FAVORITE SHOW THAT YOU SAW LAST YEAR?
Favorite show that I saw last year was Tool's second night at the Wiltern Theatre in Los Angeles. A good show has to be entertaining the entire time, and Tool is entertaining visually and has a whole bunch of music playing behind the monitors the whole time. So it's visually entertaining as well as the music.

WHAT ARE YOUR FAVORITE MOVIES?
Top three—I like *Saving Private Ryan*, *Half Baked*, and the *Star Wars* films.

WHAT IS A TYPICAL DAY LIKE FOR YOU?
I get up at nine A.M., have my home schooling from ten A.M. to noon. Then I'll work out, and it depends what day of the week it is, but then I'll go to work—I work at Epic as a scout. I go in three times a week. I found one band over a year ago that has a development deal right now. I'm waiting for the higher powers to give the okay.

WHERE DO YOU GET YOUR INFLUENCES FOR STYLE?
I don't really get influenced by people. I wore black Dickies for two years straight and a black t-shirt. These are the first pair of jeans I've bought in eight years. I kind of do my own thing.

WHAT IS YOUR FAVORITE THING TO DO WITH YOUR FRIENDS?
Hang out, really. I go out to a lot of clubs; it's a good time. Sometimes we'll just sit in my room, and we'll listen to music and just talk and watch a movie. Or sometimes we'll just go out.

DO YOU KNOW WHERE YOU WANT TO LIVE WHEN YOU GET OLDER?
I'm not moving out. I'm in no rush to pay rent! I think kids are really pathetic when they get to the point like, "I'm moving out, I can't stand you," and then they move out and they can't afford to live. I want to live wherever my friends are; that would make me happy.

HAVE YOU EVER BEEN TREATED DIFFERENTLY BECAUSE OF WHO YOUR PARENTS ARE?
Of course, living in L.A.? Every day. Its ridiculous; it's a hard time knowing who your friends are. I mean, if I was just a regular kid, half the people wouldn't even come up and acknowledge my existence. So I don't think Kelly realizes this, but half her friends have nothing in common with her.

WHAT MAKES SOMEONE A TRUE FRIEND IN YOUR EYES?
I don't know, you just connect with someone. I really don't stray away from my friends. I have got this group of six or seven friends; I don't hang out with anyone except for them. What makes a good friend is when they start caring—when you're sick, or they actually call you and see how you're doing. You can tell who's your friend and who isn't. L.A. is particularly tough. You walk down the street and people kiss your ass twenty-four hours a day, and I don't think this show is going to help much.

JACK:

"YOU WALK DOWN THE STREET AND PEOPLE KISS YOUR ████ING ASS 24 HOURS A DAY."

Kelly

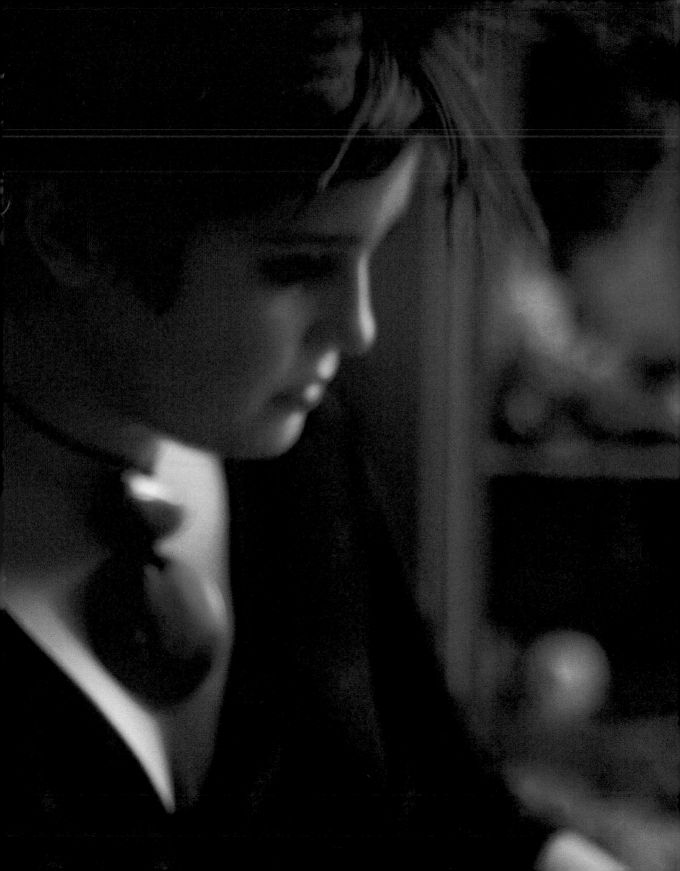

KELLY OSBOURNE

BORN:
October 27, 1984/Scorpio (strong Sagittarius/Capricorn influence; an intensely focused "bundle" type chart)

RULING CARD:
8 of Hearts

FAVORITE BANDS:
Incubus, The Hives, The Strokes, and Starsailor

ABOUT *THE OSBOURNES*:
"I hated it. I don't like looking at myself like that because you see yourself as other people see you. Your voice sounds different, and you notice all your habits. It's not that I don't like myself, but watching that much makes you uncomfortable."

HER PARENTS SAY THIS ABOUT KELLY:

SHARON:
"Ever since Kelly was born, she has what we call a *wobbler*."

OZZY:
"It's kind of like a freak-out. She's had a wobbler every day since she's been living."

JT:
"Kelly loved being around the cameras when she was in the house. She didn't like it when she went out. She had a real love-hate relationship with the attention. If Kelly said she wasn't doing something, that was it, she did not do it and you couldn't change her mind."

MEET THE OSBOURNES ┆ †

KELLY'S PROFILE

"KELLY DEFINITELY DOESN'T TAKE AFTER SHARON, AND SHE DEFINITELY DOESN'T TAKE AFTER ME," OZZY SAYS. "SHE'S—SHE'S JUST KELLY."

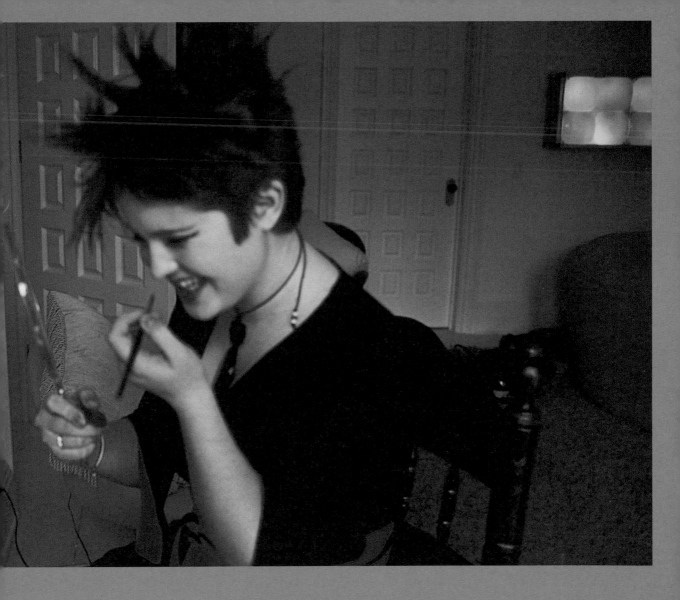

Indeed, Kelly is an original, a free spirit who lives in the moment. "I don't look at myself as a typical teenager or any other way," she says. "Why bother thinking about such things that don't matter? I just get on with it. I'm not obsessed with myself."

Kelly is all about attitude and style. Just take a look at her hair. Listen to what she says about it: "I don't really care what people think of my hair—if they like it or not. It's not their hair, so I don't really care."

Who does she think dresses really cool? "No one," she says. "Not today. I think everyone dresses the same and boring. And if they do try to be a little different, it's just too much." Her influences aren't difficult to guess: "old Madonna and Cyndi Lauper."

Like her mom, she's a smart girl, but don't ask her about math. "I #$&*ing hate it," she bristles. "Unless you're going to be a construction worker or an accountant, why the #$&* do I need to know trig or anything like that?

"Like they try to teach you to be a well-rounded person, yes, but they're making my life hell in the process. I'm good at science and history. They're my favorites."

Mandy Moore film, and I cried four times in it. I'm not s**tting you! I saw that and I'm thinking, Oh my God, I'm such a f**king idiot, I'm crying in a Mandy Moore film. But she was halfway decent in it, and it made me cry. So was the rest of the theater, even the guy sitting next to me that looked all tough in his Fubu and gold chains—he was even crying. It was just like, "Oh God, this is so sad!" That's kind of embarrassing.

WHAT IS THE BEST CONCERT YOU'VE EVER BEEN TO, OR YOUR FAVORITE SHOW IN THE PAST YEAR?
I did see a lot of good bands last year. I didn't get to stay very long, but I really like this band called Ecreslin; they're really good. Last year I saw the D, Tenacious D. They opened, I think, for the Foo Fighters, I can't remember, but they were really good. And the Incubus show was one of the best shows I've seen so far. They played the Universal Amphitheatre, and it was really good. I've seen them like thirty-five thousand times now.

DO YOU HAVE A CITY THAT YOU WANT TO LIVE IN WHEN YOU GET OLDER?
New York. There's a sense of independence there. And you don't have to drive. If you want to you can walk. It's halfway between L.A. and England, so you get a mixture of both types of people. I think people in L.A. are so concerned about how they look or who they know, and what their life story is with money and whatever. It's not such an issue [in New York]. Well, maybe it is, depending on what group you associate yourself with. I think L.A. is filled with so many struggling people, striving to find something that most of them will never find, and in the process they're just making themselves miserable. I mean, when you're young, like twelve or thirteen, it's fun to live here [in L.A.] because there are lots of little things to do. But when you get older, the actual people that are here just seem so unhappy all the time. Everyone's so skinny with fake t**s and blond hair. I kind of don't fit into that here.

WHERE DO YOU GET YOUR INSPIRATION FOR STYLE? WHO DO YOU THINK DRESSES COOL?
No one today. I think everyone dresses the same and boring. And if they do try to be a little different, it's just too much. Like, in England there was this crazy model named Zandra Rhodes. And she's like this amazing woman who'd have a different poster and the money would go to charity. The way she still dresses is amazing. Like old Madonna and Cyndi Lauper, that kind of thing.

DO YOU HAVE ANY FASHION INFLUENCES?
No. But do you know what I've noticed? Colors have a lot to do with what you wear or buy. Some days the only things I'll buy are blue. Other days everything is pink. I think it has to do with mood.

ARE YOU AS MUCH OF A SHOPPER AS YOUR MOTHER?
I think I'm a little worse sometimes. No, no one is quite as bad as my mom, though I think I'm almost on that level.

DO YOU HAVE ANY FAVORITE PLACES TO SHOP?
I find stuff almost everywhere. In L.A. I like Fred Segal, and I like a lot of vintage stores.

WHAT IS YOUR FAVORITE CD OR CDs OF ALL TIME, AND WHAT ARE YOU LISTENING TO NOW?
I don't really have a favorite CD of all time, because I haven't really lived. It's the kind of question where, like, in twenty years maybe I'll know what's my favorite CD of all time.

WHO ARE YOUR FAVORITE POP STARS?
God, #$&*, no! I hate pop stars. What's to admire about them? They're all full of #$&*.

WHAT IS A RECENT FILM YOU SAW THAT YOU LIKED?
This is really sad and kind of embarrassing, but I saw that

WHAT'S YOUR FAVORITE THING TO DO WITH YOUR FRIENDS?

Just talk s**t, like when we go out, we just go to clubs and stuff. My favorite thing to do is to go to one of the chichi clubs where all the celebrities hang out and put sunglasses on and just watch all of them. Because they really *are* the most ridiculous people. Like, seriously, it's so fun to watch. I'm probably more ridiculous than them but it's just fun to watch.

WHAT DO YOU THINK ABOUT YOUR SISTER AIMEE'S DECISION TO STAY OUT OF THE SHOW?

I couldn't give a #$&*. I also wasn't surprised.

WHAT DO YOU THINK ABOUT HER?

We are each other's alteregos, if you know what I mean. No one can make me laugh like she can if she's in a good mood. When she's in a good mood, she's just hilarious. But when she's not in a good mood, forget it. I don't get along with her.

WHAT'S SHE LIKE?

She's very clean-cut, very proper, very reserved. I don't really want to talk about her.

KELLY: "I HATE POP STARS. WHAT'S TO ADMIRE ABOUT THEM? THEY'RE ALL FULL OF ."

Sharon

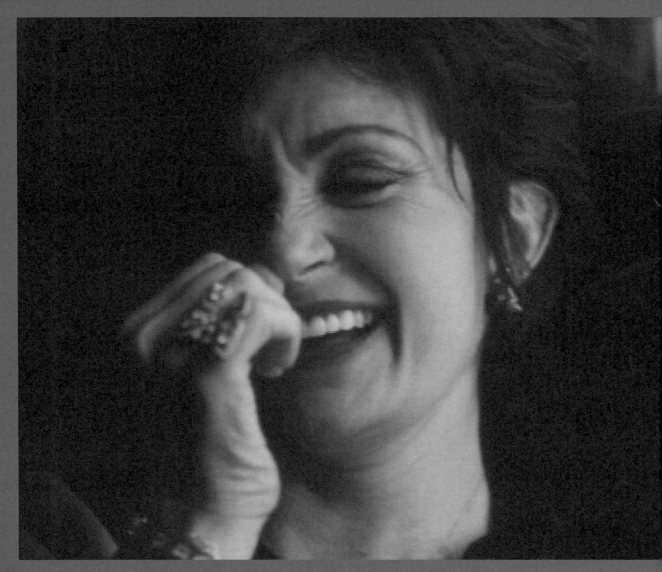

SHARON'S PROFILE

After she told her son to "shut the #$&* up and go to bed" in the opening moments of the first episode of *The Osbournes*, it was clear Sharon Osbourne wasn't your typical TV mom, and by the last episode—the one in which Kelly squealed, "She's wiped her finger on her vagina and she's going to wipe it on me"—we knew she wouldn't have it any other way. "I can't sit here and say, like, you know, 'I'm really the next Mother Teresa,'" she declares. "I'm Ozzy Osbourne's wife."

SHARON OSBOURNE

BORN:
October 9, 1952/Libra (four planets in Libra)

RULING CARD:
King of Clubs

BIRTHPLACE:
London, England

FAVORITE CDs:
Queen (big, big fan), Led Zeppelin ("Stairway to Heaven"/*Led Zeppelin 4*), Vivaldi (loves *The Four Seasons*), and Black Sabbath (duh). She also likes Coldplay and Foo Fighters.

OZZY ON SHARON:
"Whoever said women are the weaker sex never met my wife. She never stops. She's an absolute completely lunatic workaholic. I say to her, 'Even God had a day off.' But I love her madly."

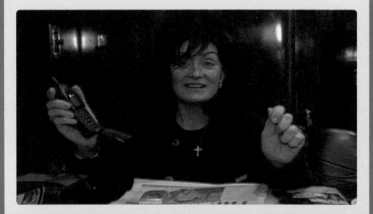

Ozzy boasts of her strength. "She's the leader," he says. "We all depend on her for everything. I'm like the monkey on the piano. I do the jumping. She plays the tunes." Born and raised in London, she dropped out of school at fifteen and worked for her father's music management company. In 1979, she struck out on her own by signing Ozzy—and also falling in love.

"He was completely original and honest," she says. "I thought he was cute."

"I was first attracted to her laugh," says Ozzy. "She was also #$&*ing brilliant. And a great lover."

According to Sharon, the loving hasn't ever stopped, though there have been changes. "He started to take Viagra, and we would wait and wait for it to work," she said. "I'd fall asleep and he'd be there with a big boner and I'm fast asleep and he can't wake me up."

Opinionated and outspoken, Sharon knows what she doesn't like: "I hate washing up. I hate cooking. I am never doing it again. Martha Stewart can lick my scrotum. Do I have a scrotum?" Likewise, she knows what she likes and wants: "The Virgin Mary speaks to me," she announced. "She said you must go to Tiffany. And on the way, stop at Cartier."

WHY DO YOU THINK PEOPLE RELATE TO THE SHOW?

They can see that we love each other and love to be with each other. A lot of families with children around the ages of my kids don't want to spend time together. We do. But it's not to the point where it's over-the-top. We still have our issues, the same as any other family. Yes, we come from a certain financial status, but after that we're the same as anybody else.

WHO DID YOU THINK WOULD BE THE MOST INTERESTING PERSON ON THE SHOW?

Ozzy. He's so complex. There are so many layers to Ozzy. I think he's also very, very funny.

HOW DO YOU THINK YOU'RE PERCEIVED?

As a giggling, ham-throwing nut. Seriously. I'm like any other mom. Moms are the people who keep a home and a family together. That's what I do. People like to put a spin on it and say I wear the trousers. But Ozzy's not going to pick out curtains or help the kids do things. Guys don't do that stuff. They don't know how to make a home. It takes a woman.

JACK SAYS YOU SHOP TOO MUCH.

I do.

WHAT PLEASURE DO YOU GET FROM SHOPPING?

So much. Ever since I was a little girl, I have always been surrounded by beautiful things. They give me so much pleasure. As a kid, I would spend and spend to get something that was really beautiful. I wouldn't buy fashionable clothes or whatever. With me, it was a chain of beads, a teacup, a lamp, or something I thought was beautiful. The thing is, I haven't changed. I love being surrounded by beautiful things.

WHAT ARE YOUR FAVORITE STORES?

Chanel, Barneys, Manolo Blahnik shoes, Fred Segal, Van Cleef, Tiffany, and Mont Blanc. I love pen stores for some crazy reason.

ARE YOU REALLY HELPLESS IN THE KITCHEN?

I can't cook to save my life, but I know how to make a kitchen look absolutely spectacular. I can buy the greatest appliances and make it look totally professional. I can kick Martha Stewart's ass when it comes to that.

LOVE AND MARRIAGE

"What's the strength of our marriage? Love, I suppose," says Ozzy, who was in a nine-year marriage before tying the knot with Sharon Arden. After becoming his manager in 1980, she helped him sober up, then relaunched his career as a solo artist. In 1982, they got married in Hawaii on their way to a concert in Japan. "We didn't have the most romantic wedding, but it didn't matter," says Sharon. "We adored each other. We never wanted to be apart." They had three children, survived Ozzy's fourteen trips to rehab, and now have found TV stardom. Their secret? "He's always been vulnerable, sweet, and honest," says Sharon. "He's so loving." Adds Ozzy: "She's a great lover. She's got a lot of love in her. She's the best thing that's ever happened to me."

SHARON:
"CHANEL, BARNEYS, MANOLO BLAHNIK SHOES, FRED SEGAL, VAN CLEEF, TIFFANY, AND MONTBLANC. I LOVE PEN STORES FOR SOME CRAZY REASON."

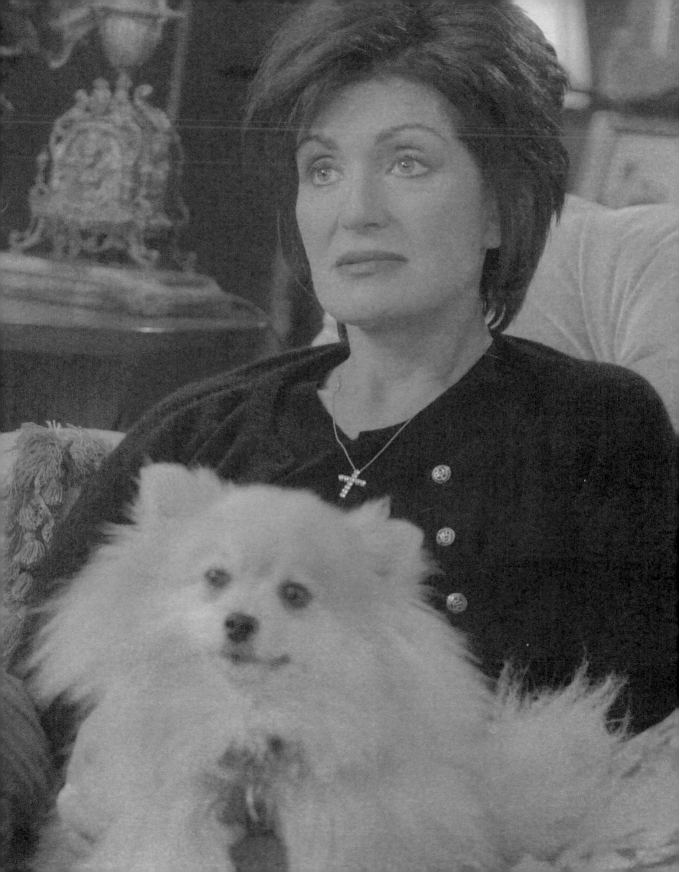

Ozzy

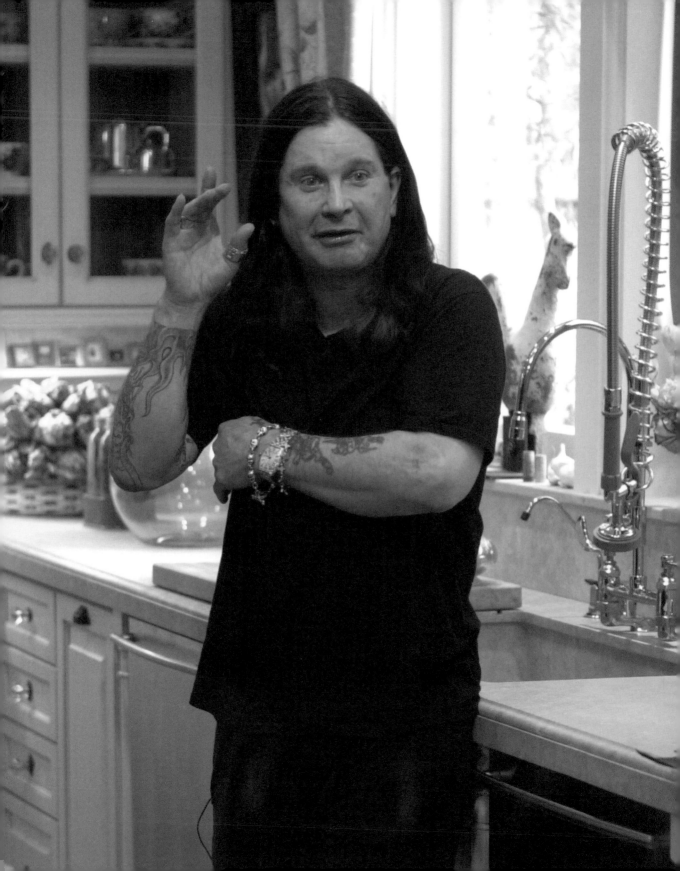

OZZY OSBOURNE

BORN:
December 3, 1948/Sagittarius (strong Capricorn influence)

RULING CARD:
2 of Diamonds

BIRTHPLACE:
Birmingham, England

SELF-IMAGE:
"I'm just a guy from Aston in Birmingham, with minimal education, who has entertained the world for over thirty years."

PREVIOUS MARRIAGE:
"I was married for nine years, but I was always away."

FAVORITE CDs:
The Beatles, Led Zeppelin, David Bowie.

DEEP THOUGHT:
"Thinking about life, by the time you get old enough to understand what it's all about, you die."

SHARON ON OZZY:
"He's the bestest husband and father in the world, and I love him."

MEET THE OSBOURNES †

OZZY'S PROFILE

He said he likes the smell of armpits in the morning because they smell like victory. Truthfully, they probably remind him that he's alive. Ozzy has done a lot of living in his fifty-three years on the planet. "I'm not the kind of person you think I am," he says. "I'm not the Antichrist or the Iron Man."

So who is Ozzy? Is that even his real name? "I've been called Ozzy Osbourne as far as I can remember," he explains. "My real name's John Michael Osbourne."

WHERE WERE YOU BORN AND RAISED?

I was born in Aston, Birmingham, England, an industrial part of the country. I'm the middle child with three older sisters and two younger brothers. My mother and father worked in a factory. My mother tested car horns, and my father made tools.

WHAT WAS YOUR CHILDHOOD LIKE?

I didn't like growing up. I wanted to get out of Birmingham. I always aspired to travel. I remember one day saying to my father, "I want sex and travel," and he said, "#$&* off."

HOW ABOUT SCHOOL?

I couldn't stand school. I was dyslexic, hyperactive, and my teachers told me that I was dumb. I rebelled all the time. I didn't want to take the time to learn. Now I wish I had taken more time at school, but then I was bored and couldn't stand authority figures.

WHAT DID YOU SEE YOURSELF DOING IN LIFE?

I had little ambition. At fifteen, I dropped out and worked a bunch of lousy jobs, including stints as a plumber's assistant, a house painter, and an animal killer at a slaughterhouse. I planned on becoming a drifter. I tried burglary, but I was a piss-poor criminal. I tried to steal a television set but #$&*ed that up and spent six weeks in Winson Green Prison, which was where I got my first tattoos—OZZY across my knuckles and these happy faces on my knees so I'd get a little cheer every morning when I woke up.

WHEN DID YOU GET INTO MUSIC?

I always liked music. I would like to have learned to play an instrument, but that couldn't happen because my father slept during the daytime, and he would've thrown my amplifier up my ass. Then the Beatles came along, and I fell in love with what they were. I sang their songs all day long. I thought being a Beatle would be a great way to get out of Birmingham. I used to dream that Paul McCartney would marry my sister. That was going to be my ticket into the Beatles. Unfortunately, Paul wouldn't have liked my sister.

BUT YOU STILL MADE IT?

Music was the only thing I was interested in. I put up an ad on a local board and got involved with a bunch of bands before a few of us started Black Sabbath, which we named from a Boris Karloff movie. Since I was always walking around singing Beatles songs, my friend said, "Why don't you have a go at singing for a couple of gigs?" I did and I liked it. But I remember being scared as %$#@ at the first gig. I wondered if I was going to pull it off.

AND NOW YOU'RE THE PRINCE OF DARKNESS.

The Prince of #$&ing Darkness. People honestly think that I live in a Bavarian castle, hanging upside down off a rafter, you know, with the rest of the bats. I'm not proud of being dyslexic or having attention deficit disorder. I'm not proud of being a drug addict/alcoholic. I'm not proud of biting the head off a bat and or biting the head off a dove. I'm not proud of a lot of things. But I'm a real guy. With real feelings. And I suppose that kind of scares me sometimes. Um, to be Ozzy Osbourne—it could be worse. I could be Sting.

SEVERED HEADS: OZZY ON BATS AND DOVES

"Everybody makes a big #$&*ing deal, but it's not like I bit the heads off of animals all the time."

Des Moines, Iowa, January 20, 1982:
Ozzy bites the head off a live bat thrown onstage during his "Diary of a Madman" tour.

"At the time, kids were throwing all kinds of crap onstage. Snakes, raw meat, and #$&*. They also threw bats. I thought it was one of those Halloween type rubber things. Where the #$&* is some kid going to get a bat from? I just put it in my mouth and bit on it. But this #$&*er was a #$&*ing real one. I couldn't believe it. I didn't want to bite something with rabies in it. Actually, it tasted a hell of a lot better than my wife's cooking."

Los Angeles offices of Epic Records, Summer, 1980:
Ozzy bites the head off a dove.

"Sharon and I were at a marketing meeting, and the song "Crazy Train" was playing on the stereo. We had brought some doves as part of a publicity idea. I had them in my coat pocket. One landed on this publicist, this girl, and I just picked it up, put its head in my mouth, and ripped the #$&*ing thing off. This carcass was flapping all over the place, and people were throwing up. They were horrified. We were told never to come back. Why did I do it? Why do people do anything? I was out of my head from having drunk a bottle of cognac. I'm absolutely sure if you go around to most bars late at night you'll see crazier things."

OZZY:
"I REMEMBER ONE DAY SAYING TO MY FATHER, 'I WANT SEX AND TRAVEL.'"

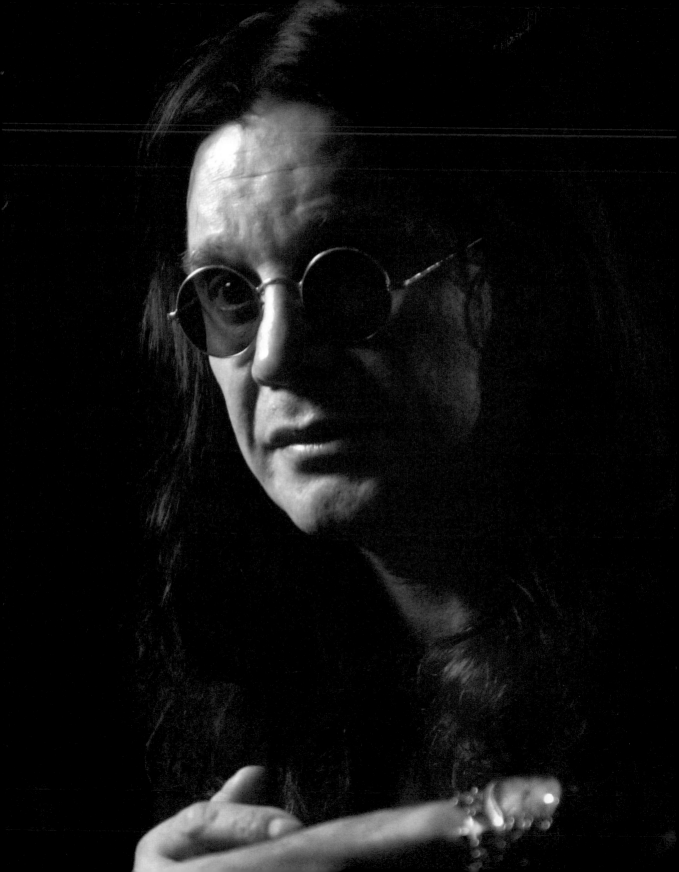

Episode Guide #2:
Bark at the Moon

Guess what? The self-proclaimed "Prince of #$&*in' Darkness" likes to snuggle with his dogs—all seven of them. Meet Maggie, Lola, Lulu, New (Crazy) Baby, Minnie, Pipi, and Martini (the "gay one"). Ozzy and Sharon's love of their pets is undeniable. It is not, however, strong enough to keep them from shredding the furniture and peeing in the house. Lola, Jack's English bulldog, continues to eat away at the furniture and "#$&* aliens" in the house, while Minnie, Sharon's precious Pomeranian is nothing short of a "little bitch," according to Kelly.

In typical Beverly Hills fashion, Sharon hires a "dog therapist" to better train the dogs—specifically Lola. Meet Tamar, a strong blond Israeli chick and professional dog trainer. Ozzy thinks it is simply ridiculous. *(Sequence #1)*

Sequence #1: DOG THERAPY

THE PARTICIPANTS:

START°

While the famous parents have their pooches to keep them company, Jack and Kelly have famous friends to accompany them. In perfect Hollywood style, the Osbourne offspring invite Elijah Wood and his sister, Hannah, over to the house. Only the night before, Kelly was pulled over for a speeding ticket, but no matter, punishment was a hug from Mom and a side comment from Dad ("she's #$&*ed"). And so, Kelly and the rest of the motley crew go to hear Billy Corgan (previously of Smashing Pumpkins) play with his new band. Back at the house, Kelly tells her parents she thought the band sucked. ("I thought it was really boring. It was like elevator background music"). But could the concert have really sucked more than spending Saturday night after-hours cleaning Lola's piss off the sofa pillows? Ask *Lord of the Rings* star Wood—that's what he ended up doing back at the Osbournes'. *(Sequence #4)*

START°

START°

Sequence #2: OPEN THE #$&* DOOR! THE PARTICIPANTS:

OZZY:
"WHAT'S THE DEAL SHARON?! IT'S NOT LIKE IT WAS A LITTLE PISS–IT MUST HAVE AN EXTRA TANK IN ITS ASS!"

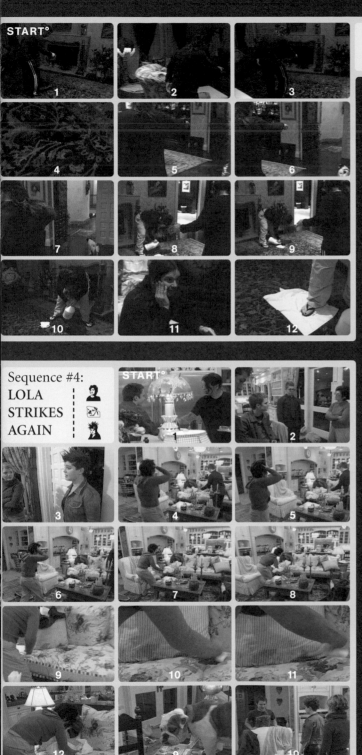

Sequence #4:
LOLA STRIKES AGAIN

BEST LINES

† **Kelly:** "Mom, Aimee wears a thong every single day, and right now she's wearing a thong of mine. So it's been up my crack and now it's up her crack, and I'm not down with that."

† **Ozzy:** "Who pissed? That #$&*in' dog, get the #$&* out of my house! They're terrorists! They're #$&*in' part of bin Laden's gang! What's the deal, Sharon?! It's not like it was a little piss—it must have an extra tank in its ass!" *(Sequence #3)*

† **Ozzy:** "Don't get me wrong, sweetheart, I adore Lola . . . but she's trying to destroy me." *(Sequence #2)*

† **Ozzy:** "Why can't we get a Lassie-type dog—a dog that does tricks. Mind you, I'm not picking up another turd. . . . I'm a rock star."

HIGHLIGHTS

† Ozzy flips out over the dogs' peeing inside the house and compares the family pets to bin Laden's gang.

† Lola pees on the carpet just as the trainer is leaving the house and saying what a good dog Lola is.

† Elijah Wood drops by and helps Jack clean dog pee off the sofa pillows. *(Sequence #4)*

BAD WORD BOX SCORE

46 12

13 9

At Home with

the Osbournes

AT HOME WITH THE OSBOURNES ✝ Chapter III

When MTV arrived with their cameras and crew at the start of the second week of October 2001, the Osbournes were moving into their new Beverly Hills mansion. Viewers never saw where they lived before, and ever since the show's March 5, 2002, debut, many have wondered if their new residence was a made-for-TV or real life move. Did they suddenly strike it rich, like the Beverly Hillbillies? Or were they a proper English rock-star family in love with L.A.?

For starters, the Osbournes' real home—their house back home in England—is a stunning twenty-room Edwardian mansion on eighteen lush acres, including a deer park, in Buckinghamshire, about thirty miles north of London. Sharon has decorated it exquisitely with antique furniture, lamps, and artwork, and though Ozzy occasionally says, "I get sick when I realize Sharon has paid fifty thousand dollars for some #$&*ing vase," they treasure this palace. "We'll always keep that house," Sharon says. "It's where our babies grew up, and they adore it. We should spend more time there than we do."

Where were they living prior to their present house seen on TV? They owned a large Mediterranean home adjacent to the famous pink Beverly Hills Hotel. "Ozzy doesn't drive and the kids were all at school," Sharon explains. "I wanted a place that was convenient for the school bus to pick them up in an area that was safe and familiar. Ozzy could walk to the shops and to the hotel, and the kids could have their friends come and go. But we kind of outgrew the house."

When it was time to move, Sharon and Ozzy were keen on a Spanish-style mansion from the 1930s, but they weren't able to get it. Singer Lionel Richie beat them to their dream house, and Sharon and Ozzy bought their present home on the rebound. There was just one problem—they hated it. It sat vacant for a year. Finally, Sharon said, "This is a ridiculous waste of money," and she decided to gut the mansion completely and redo it to their liking.

Eighteen months later, as MTV's cameras recorded, the Osbournes finally moved in. Their newest home—Sharon estimates her kids have lived in twenty-four—is a gorgeous two-story Beverly Hills estate, a mansion with heart and soul and all the stan-

dard rock-star luxuries in case pals like Marilyn Manson or Incubus drop by, including a billiards room, a Jacuzzi, a screening room, a guest house, and a sick pool with a slide.

The pool was a major source of headaches and confusion as they moved in. In one of the memorable scenes from the first episode of *The Osbournes,* Ozzy couldn't tell if it was a pool or a pond. "It's a #$&*ing swimming pool," Sharon said. "And the guy that's building it, I'm going to drown the #$&*er in it."

The move tested each of the Osbournes in different ways. Sharon grew increasingly upset as she found her precious antiques broken. "Everything we open is broken," she said. "And they keep saying to me, 'Oh, glue it.' I'm going to glue his #$&*ing mouth." Then Jack was completely grossed out upon discovering intimate articles not belonging to him buried in his stuff. "Dude, how is it my sister's underwear gets mixed up in mine?" he asked. "You know, that's just wrong." Kelly was unperturbed by the mess piling up in her room ("I think cleaning is a disease," she says), and a frustrated Ozzy sat in the kitchen trying to figure out how to work their new flat-screen TV. "Jack! Why can't I get a normal #$&*ing TV, man? I press this one button and the shower starts. What is this? Where am I?"

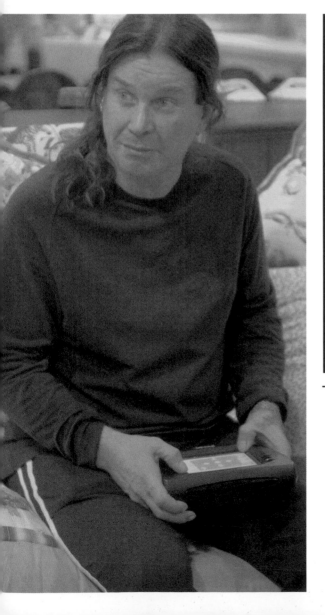

OZZY: "I'M A VERY SIMPLE MAN. YOU'VE GOT TO HAVE, LIKE, A COMPUTER NOWADAYS TO TURN THE ING TV ON AND OFF . . . AND THE NIGHTMARE CONTINUES."

Ozzy's
TOP 5 THINGS TO WATCH

1	THE HISTORY CHANNEL
2	THE LEARNING CHANNEL
3	THE DISCOVERY CHANNEL
4	A&E
5	M*A*S*H RERUNS

The Osbournes' home is imprinted with their unique sense of style and warmth. Upon entering, you are struck by two things—the breathtaking beautiful décor and the enormous number of framed family photos. (Okay, you also have to watch your step because of the dogs, but that's another chapter.) Despite its size and elegance, the house is a hangout for family and friends, made cozy by Sharon's fondness for mixing different styles.

"I like creating a mood in a room," she says. "I don't think I'd be any good at feng shui. It's way too minimalist for me. I pile so much crap onto a table you can't even fit a teacup. But I like being surrounded by a lot of crap."

ESPECIALLY ANTIQUES, RIGHT?

I love antiques. I like old tables where you see all the markings. I love that. They make me think of all the people that have stopped at those tables. I have a table at home in England, and there's a heart cut into the table with people's initials inside the heart. It's three hundred years old, and I got it just because of that.

HOW DOES YOUR HOME REFLECT YOU?

I suppose it's hard when, say, you're doing the bedroom. It would be hard for me to do a particularly feminine bedroom when I'm married to Ozzy. I couldn't put him in pinks and ivories. It wouldn't be fair to Ozzy. But it's a kind of compromise you come to. I did his bathroom very masculine and mine feminine.

WHAT'S OZZY'S TASTE IN HOME DÉCOR?

Black.

JUST BLACK?

And crucifixes. But everything has to be very dark. Everything. As long as it's dark, he likes it.

THE HOUSE IS VERY COMFORTABLE.

Thank you. We don't usually go out a lot because we spend so much time on the road for business. When we're here, I like the children to bring their friends home and be comfortable. Ozzy and I also prefer spending the night in.

It's easier that way. According to Ozzy, it is too complicated to go out. "Usually, I'll go, 'Do you want to go out?' and she'll say, 'Yes,' but then something happens and our plan collapses before we even get out the door," says Ozzy. "For instance, while we're getting dressed, the kids will get ahold of the wine and the next thing you know— 'Mom, Kelly's called me an assh#$e.' "

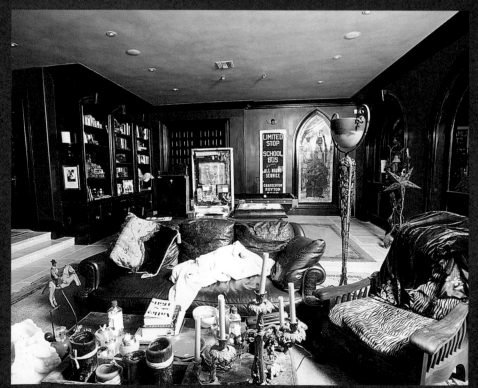

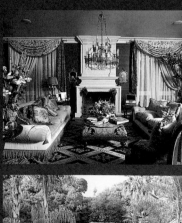

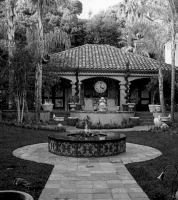

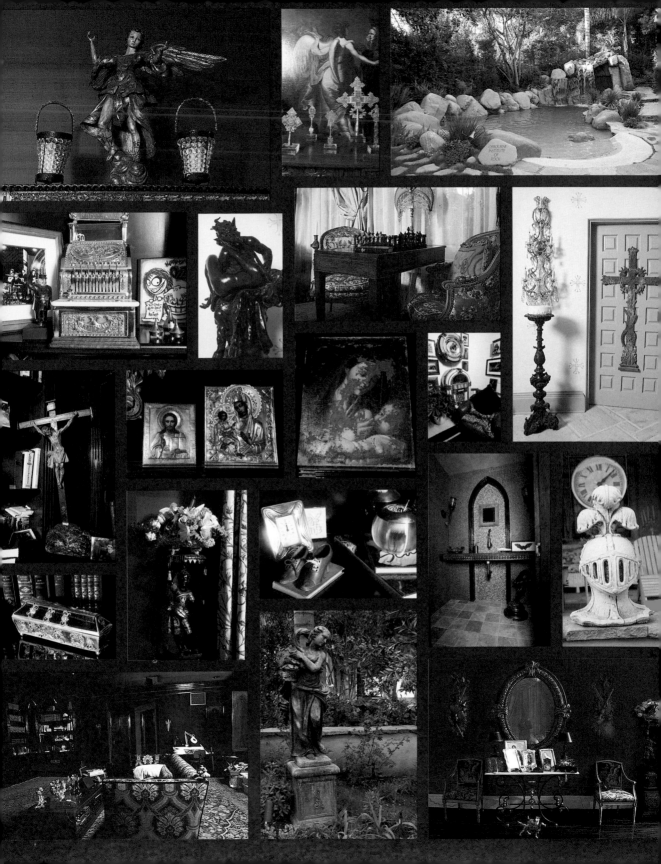

OZZY: "JACK! WHY CAN'T I GET A NORMAL ▇▇▇ING TV, MAN? I PRESS THIS ONE BUTTON AND THE SHOWER STARTS. WHAT IS THIS? WHERE AM I?"

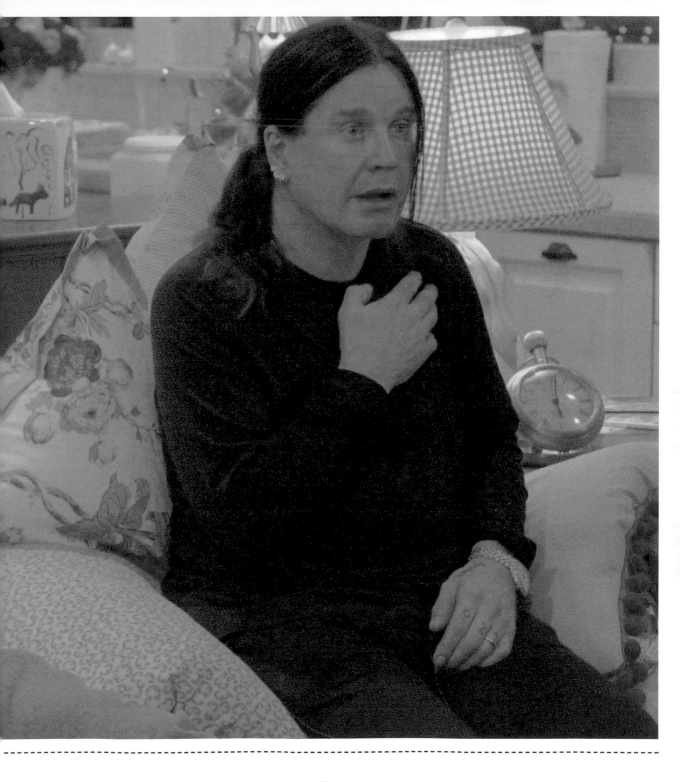

✝

KELLY'S BEDROOM

KELLY'S BEDROOM

WHO DECORATED YOUR BEDROOM?

Me. I did it myself. It's not even finished. Everyone else got these decked-out entertainment systems, with matching cabinets, rugs, and coffee tables. Just everything, and it was all sent up to their room. And you know what I got? #$&*. No, honestly, I got something this carpenter put together to hold my TV and stuff. My room isn't even finished.

YOUR ROOM HAS A VERY SIXTIES FEEL, INCLUDING THAT PICTURE ON THE WALL FROM THE MOVIE *VALLEY OF THE DOLLS*.

I read the book before I saw the movie, and I thought both were amazing. But yeah, I'm into that whole time period and the styles.

MELINDA SAID THAT YOU'RE THE MESSIEST ONE IN THE FAMILY.

What the #$&* right does she have to talk about me?

TRUE OR FALSE?

Yeah, it's true. I'm the messy one. I don't give a #$&*. I don't want to waste my time cleaning.

WHY?

I don't really care. I think being really tidy is a disease. It's a mental disease. My mess is an organized mess. I know where everything is. If you're neat, you spend all your time either looking for things or putting them away.

MELINDA ALSO SAID THAT UNTIL RECENTLY— ALMOST A YEAR AFTER MOVING—YOU STILL HAD YOUR CLOTHES IN BOXES.

You know what? I don't care what Melinda said.

AND MELINDA SAYS . . .

"Kelly keeps her stuff everywhere. I don't even bother to tell her to clean up anymore. I just do it for her. I wait till she goes out, and then I go in and pick up her clothes. She gets so mad. She yells, 'You don't need to do that for me. You aren't my slave.' I go, 'But Kelly, it makes me so happy to have everything clean.' She shakes her head without understanding and goes, 'You know what, Melinda? You're out of your mind.'"

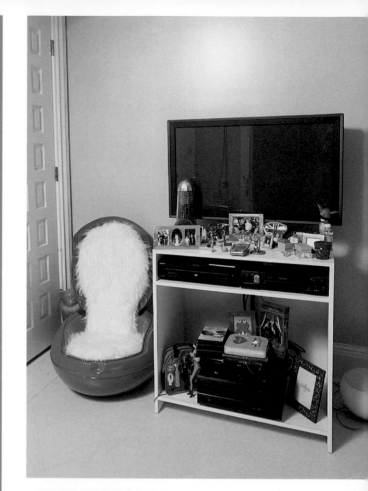

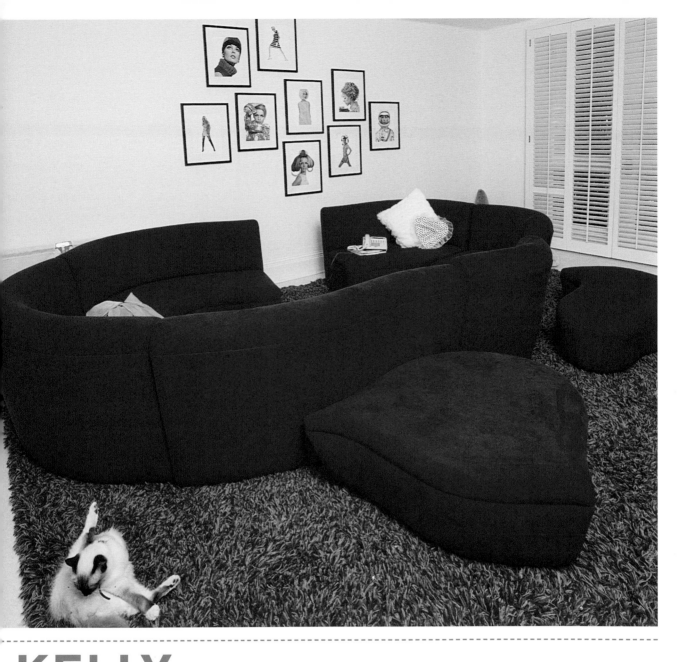

KELLY:
I DON'T GIVE A 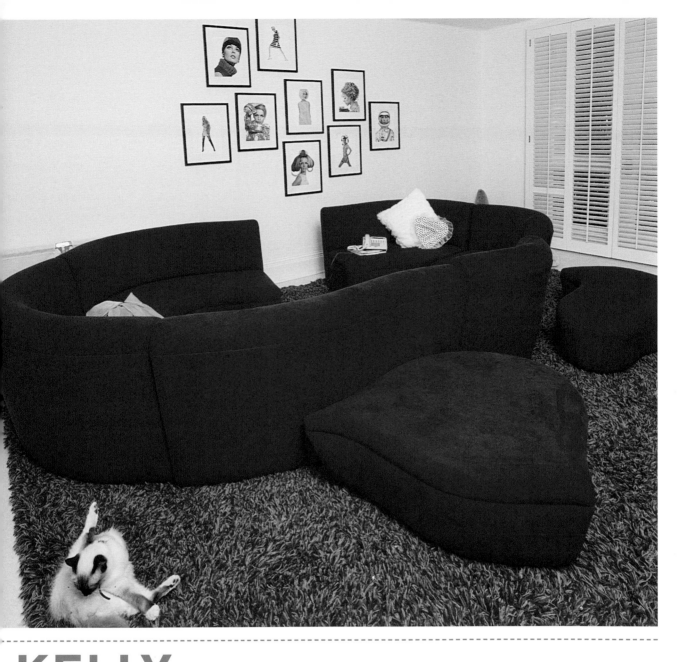.
I DON'T WANT TO WASTE
MY TIME CLEANING.

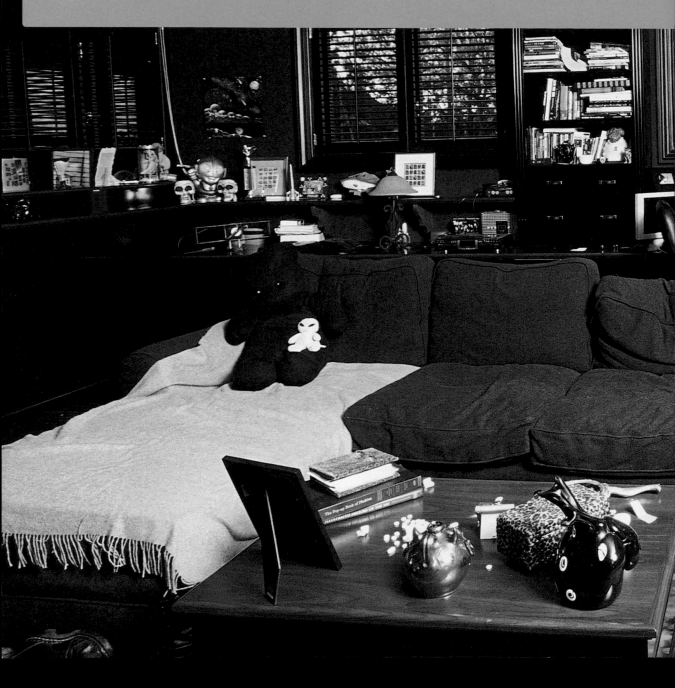

JACK'S BEDROOM

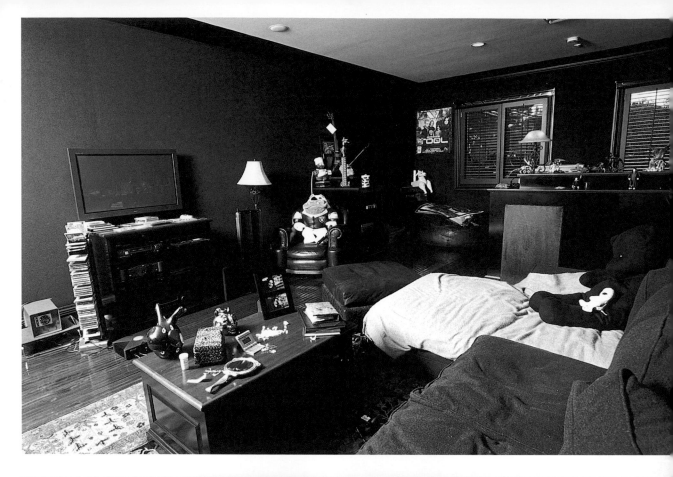
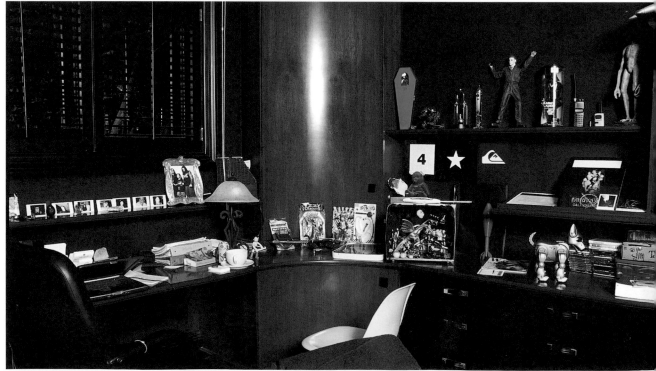

JACK'S BEDROOM

DID YOU HAVE ANY SAY IN THE LOOK OF YOUR BEDROOM?

Yeah. I mean, I'm not really the kind of person who says, "I'd like the chandelier to go here and the wall drapery over there." You know? For me, it's all basic—a basic dark wood floor, dark walls, and my #$&* scattered all around for that separation from the rest of the world. I also have a nice lovely brown bed.

WHAT DID YOUR MOTHER SAY WHEN YOU TOLD HER WHAT YOU WANTED?

She said, "All right."

HOW WOULD YOU DESCRIBE THE STYLE?

It's a bachelor pad. That's what I call it—a bachelor pad.

ARE YOU NEAT OR MESSY?

I'm kind of in-between. Usually, I'll spend time on Sundays cleaning up my room.

WHAT COOL THINGS DO YOU HAVE IN YOUR ROOM?

I like my entertainment system. Full-on flat-screen TV, surround sound, everything.

DO YOU SPEND MUCH TIME ON THE INTERNET?

Not really. I'll go on for work and do some stuff, but I don't really surf.

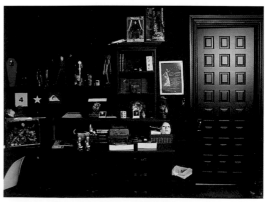

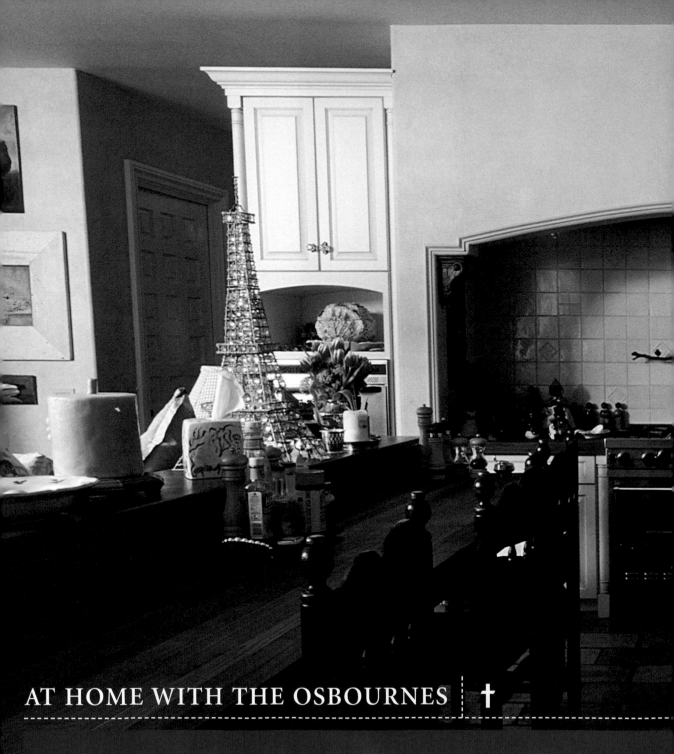

THE KITCHEN

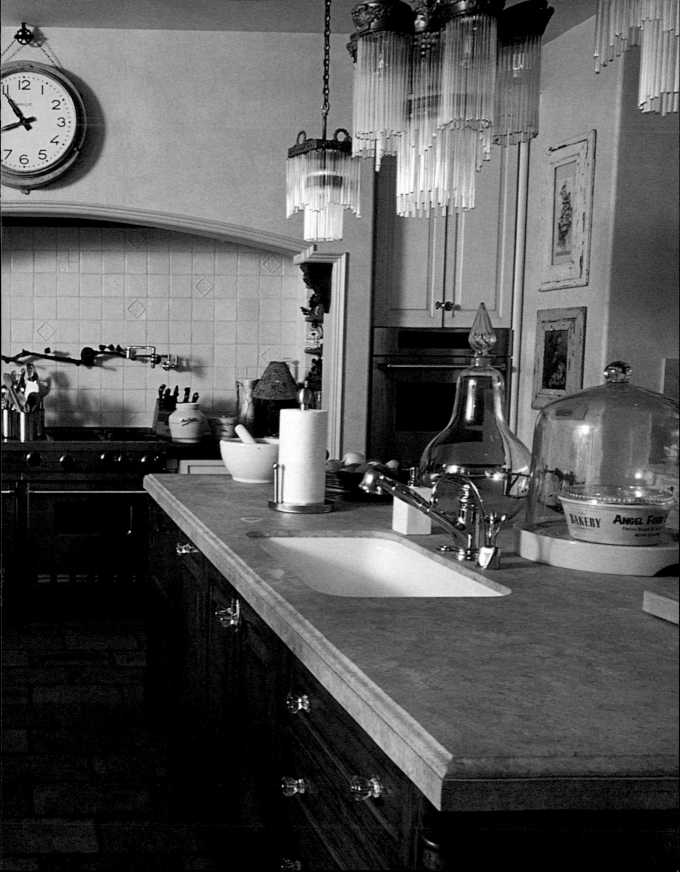

Sure, all the Osbournes have the full-on rad bedroom, but the truth is, the kitchen is the main attraction, the center of all the action in the house. "Everything happens in the kitchen area," Melinda explains. "In the morning, I walk straight in the door and I'm in the kitchen. That's the hub of all activity. Everyone is always in there, talking about something."

Ask anyone who's seen *The Osbournes* and they'll tell you that no one in the family cooks. Which is partly true. No one *likes* to cook, but in a pinch, Ozzy can muster up a roast or a curry. He also boasted about his gravy. And Jack is probably the most skilled with a skillet. "I can cook some really good chicken, steak, and pasta," he offers.

Let's be real, though. They're helpless. "Sharon is like me," says Ozzy. "She doesn't like the smell of cooking in the house."

Typically, they bring in chicken from Koo Koo Roo for dinner, but occasionally someone hankers for a home-cooked meal, just as Kelly did in the final episode when she had both parents in the kitchen and said, "I'm hungry, make me dinner. Be a mother."

"Be a mother?" Sharon said, laughingly. "You . . . cow."

"Make me food," Kelly said. "You never . . . haven't made us dinner in so long. Why don't you? Please. Come on, Mom."

"I hate the smell of cooking, Kelly."

"Well," Kelly replied, "if you make pasta, it doesn't smell."

"What?" Sharon asked.

Then Ozzy entered the conversation. "What do you want me to do for you, um, Kelly?" he asked.

"I'll make it," she said. "It's all right. Mom doesn't know how to cook."

Sharon took offense."Kell, how about . . . mmmm."

"How about you make me a nice sandwich, Mom?" she suggested.

"Bacon?" Sharon asked.

"No," Kelly said. "Turkey."

"How . . . ?" Sharon said. "I can do that. Would you like—"

"What kind of sandwich would you like?" Ozzy asked.

"I'll make it myself," Kelly said, resigned to the fact that it was all too much for her parents.

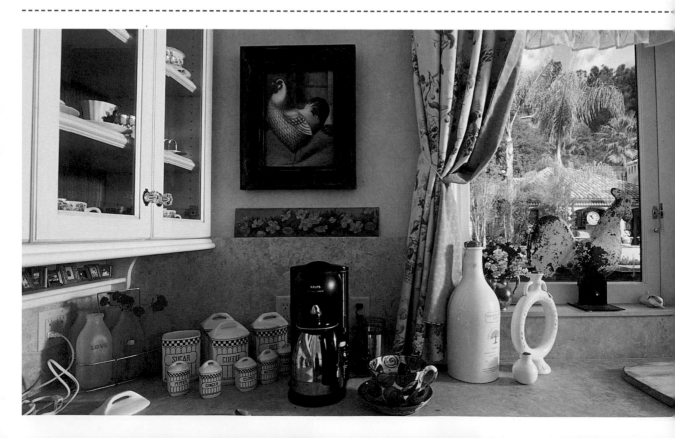

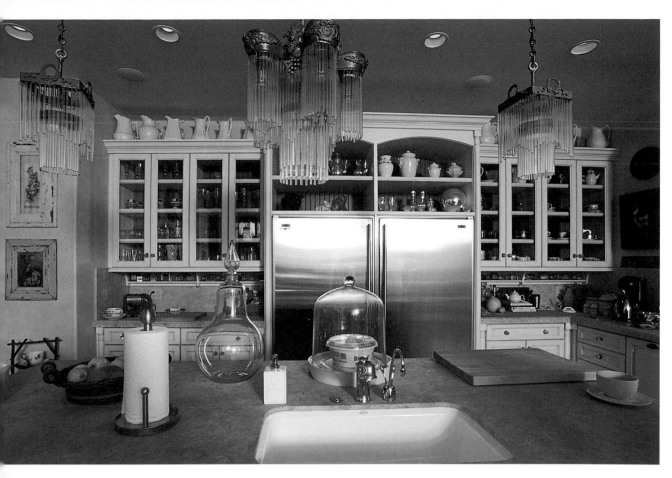

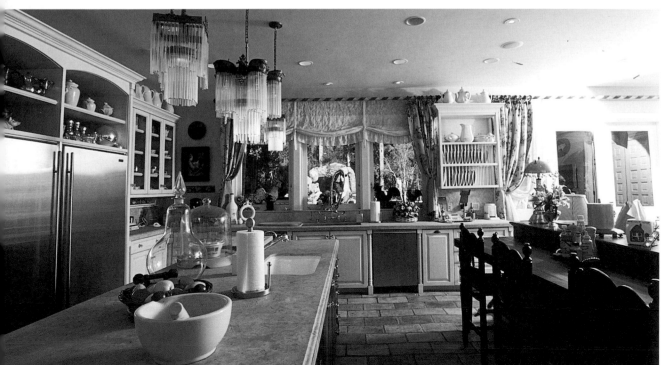

Is there a daily routine? In theory, Jack and Kelly get up around nine A.M. so they can be prepared for homeschooling, which starts at ten and lasts till noon. Jack gets his head going with hot chocolate or coffee and a Zone bar or toast. Kelly starts her day with either toast or soup.

If it's not a school day, they sleep well into the afternoon, and Ozzy is the first person downstairs, shuffling into the kitchen late in the morning, followed by Sharon, with Minnie tagging behind. "Everyone sits around and has a cup of tea," says Melinda. "The family and the staff. It's how we start the day."

We know what Ozzy does for a living. But do the kids have chores? "On the weekends, I do try and ask the children to help empty the bins and things like that," Sharon says. "I always try to make them help out, but when it comes to actual chores, they don't quite get it."

"One trait Kelly gets from her father is that she has a talent for creating a nasty mess. God forbid the two of them shared a place together. Forget it. I find old sandwiches under Kelly's bed, half-eaten chocolates, drinks, and cans that have been there for days. It doesn't bother her. Ozzy is the same. They just don't see it."

This bunch clearly isn't named Brady. Just think about the attempt to use their vacuum cleaner. Ozzy, Sharon, and Kelly looked at it as if a UFO had landed in their living room.

What's a typical day involve for Jack? Certainly not vacuuming the house. "It's usually hanging out," he says. And staying up till two? "No, I stay up to, like, five." Kelly's average day is fairly similar, except she will go to bed earlier. "But we have all the same friends," Kelly says. "We go to the same places. I mean, every night we want to go out, we go out together."

Jack and Kelly bring their friends (actor Elijah Wood and Kelly's pals Robert and Jessica) back to the house at all hours of the day and night. That's Mom's orders. "I tell the kids to bring anybody home," Sharon says. "Do what you want, but bring people home. I want them to use the phone at night. I want them to stay. It is their home, too. Yeah, if I had my way I wouldn't have the phone ringing at three in the morning, but they do. It's like, hey, they live here, too."

OZZY: "My house is like a revolving door. It's like the after-hours nightclub. I'd like that to stop, because I'm lying in bed and this pinball machine is rattling till five in the morning!"

The only predictable part of the Osbournes' home is their unpredictability. It took a while for the MTV crew to discover this and adapt. "Originally, I had the crew showing up at eight in the morning," says JT. "But it soon became evident that was a total waste of our time. We'd arrive and it was dead. Nothing was happening. Our call times got progressively later as the season continued. We realized the Osbournes are total nocturnal animals. Sometimes nothing stirred in the house until two P.M., and sometimes later. How many times can you shoot the exterior of the house, waiting for someone to wake up?"

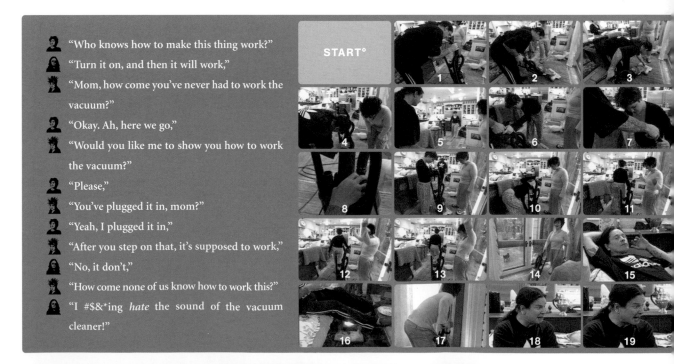

"Who knows how to make this thing work?"

"Turn it on, and then it will work,"

"Mom, how come you've never had to work the vacuum?"

"Okay. Ah, here we go,"

"Would you like me to show you how to work the vacuum?"

"Please,"

"You've plugged it in, mom?"

"Yeah, I plugged it in,"

"After you step on that, it's supposed to work,"

"No, it don't,"

"How come none of us know how to work this?"

"I #$&*ing *hate* the sound of the vacuum cleaner!"

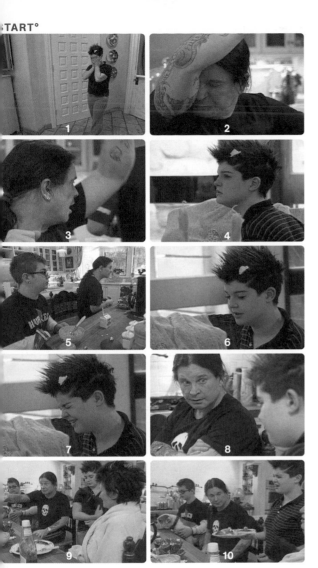

OZZY: "...I'M LYING IN BED AND THIS PINBALL MACHINE IS RATTLING TILL FIVE IN THE MORNING!"

Keeping the camera crews there until two A.M. turned out not to be late enough. About a month into production, JT discovered that a lot of activity took place at four A.M. He left the security cameras on so he could see what the heck went on at that hour. "Well, what would happen is that Sharon and Ozzy would go to bed at two, and all hell would break loose around three," he says. "Someone would come home from a nightclub or someplace, and soon everyone was up, shouting.

"So we pushed the night crew till four in the morning, which changed everything. A lot of the nights they'd be complaining that nothing was going on, and they wanted to go home. At one A.M., they would call and say, 'JT, there's nothing going on. How about we go home?' I was like, 'No, stay. Something's going to happen.' Then, sure enough, about three-thirty, all hell would break loose.

Jack and Kelly would come home from a club with a bunch of kids. They'd wake up Ozzy. He'd get pissed off because they'd woken him up. And soon everyone was in the kitchen."

The action continued virtually 24/7. Blink and you'd miss their pal Elijah Wood. Or there would be Kelly's friends, Jessica, Sarah, and Robert. Or the guys in Incubus would parade through the kitchen. Or Jack's skateboarder friend Jason Dill would be shooting pool and sucking down beers. Or it would be someone else. "Most of the time, Ozzy had no idea who any of these people were," JT says. "Jack and Kelly wouldn't even be in the house, and their friends would be playing pool. Ozzy would come down, look at them, and then turn around."

"I don't mind 'em running around," Ozzy says, "so long as they watch their #$&*ing language."

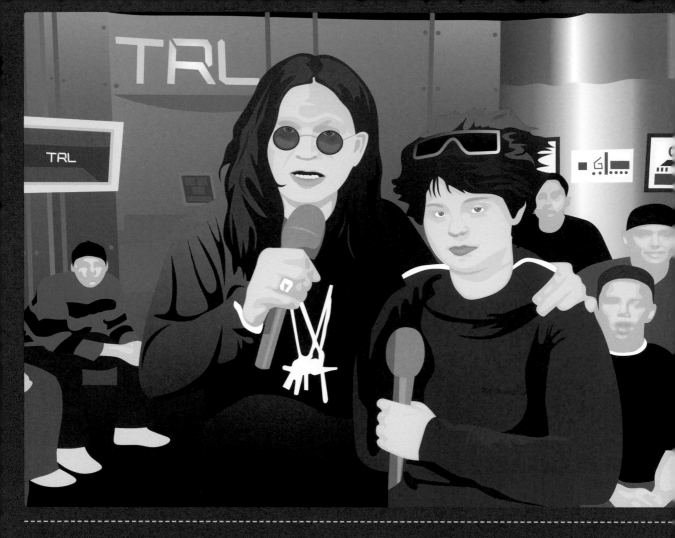

Episode Guide #3
For the Record

"When you were a kid, did you think you wanted to be a rock star?" asks an unseen source. "I wanted to be a plumber!" confesses Ozzy (in a segment before the opening credits). Of course, had Ozzy decided to be a plumber, he would never have to go on massive PR tours or get to traverse the country by private jet; he wouldn't be able to spoil his children with fame, fortune, and extravagant birthday parties, and he certainly would not be admired by everyone from babes and bikers to police officers. It appears that, had he not met his manager and muse, Sharon, he might very well be a plumber today.

1 2 3

4 5 6

At the opening of Episode #3, Sharon holds Ozzy's hand as he prepares to embark on a promotional tour for his latest album. First, she brings out clothes for Ozzy to try on for his PR tour, which he is quick to reject as "too flamboyant," "too Ricky Martin." Sharon tells him the outfit is perfect, Ozzy gives her the finger, and that is that—end of discussion. Ozzy will wear what Sharon tells him looks good.

First stop is Tower Records on Sunset Boulevard, in West Hollywood. Besides believing that he looks ridiculous ("Doesn't he look handsome?" asks Sharon. "Oh, shut the #$&* up!" responds Ozzy), the Prince of Darkness is none too pleased to be traveling by limo, or by "pimp mobile," as he calls it. Once he arrives at the store, Ozzy stops his ranting long enough to beam at the flock of fans screaming his name. All sorts of people—babies, midgets, bikers, babes—line up to take photos with Ozzy and get his autograph.

Next stop is KROQ, L.A.'s most popular rock radio station, for some sex talk with Dr. Drew Pinsky and comedian Adam Carolla, on their show *Loveline*. Jack and friends listen to Ozzy from a car radio, and Jack proceeds to cover his ears and sing when his mom and dad start to speak of firing blanks, Viagra, and boners. Sharon and Ozzy seem perfectly at ease speaking publicly about their love life—or lack thereof, as the case may be.

Then it's off to New York City for a bit more promotion: Ozzy hits the *Late Night with Conan O'Brien* show, does a radio promo (which becomes the producer's worst nightmare when Ozzy can't get the words out), and makes a stop at MTV. Meanwhile, back in Los Angeles, Jack hops a bus with his classmates to go on a camping trip. He leaves pissed off (he gives the camera the "#$&* off" sign as the bus pulls away), and he returns pissed off (he tells Melinda that he got into a bit of trouble and only had fun "#$&*ing around and breaking the rules"). Not all of the Osbourne siblings are in a foul mood, however. Kelly leaves for New York with Sharon a few days after Ozzy and joins her dad to make a guest appearance on Carson Daly's show on MTV. And when she returns to L.A., she is welcomed home with preparations for an enormous seventeenth-birthday bash.

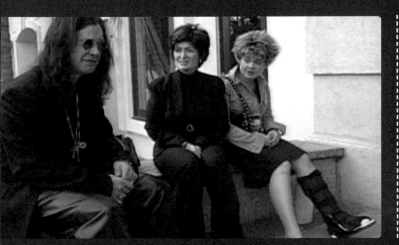

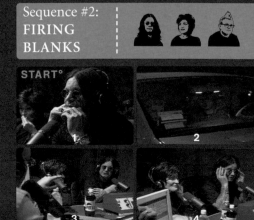

START°

1 2

3 4

1

2

4

Sequence #3:
JACK GOES TO CAMP

THE PARTICIPANTS:

3

1

2

Sequence #4:
JACK'S BACK

THE PARTICIPANTS:

OZZY:
"IT'S MUSIC TO GET YOUR BRAINS KICKED IN TO. IT'S LIKE A FOUR-HOUR-LONG RECORD, ALL THE SAME MUSIC, YOU KNOW?"

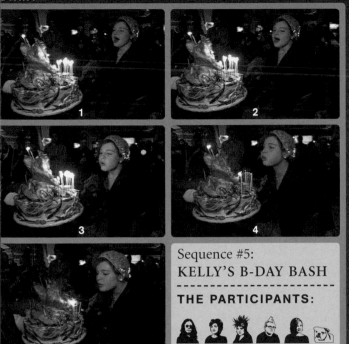

Sequence #5:
KELLY'S B-DAY BASH

THE PARTICIPANTS:

BEST LINES

† **Sharon:** Jack, how are you getting there [to the camp site]?
Jack: By bus.
Sharon: But who's driving?
Jack: A man with no legs.
Sharon: You're going to get your ass kicked by me this morning! *(Sequence #3)*

† After her kitty's examined at the vet, Kelly consoles the shaken pet: "You were violated, Puss. He shoved something up your bum."

† **Sharon:** Jack didn't like it there—the camping trip. It was too hippy-ish.
Kelly: Yeah, they make you feed a tree before you feed yourself.
Ozzy: What? What? What you gonna do, put a ham sandwich by the tree?

HIGHLIGHTS

† Ozzy stammering through his radio spot, while the dorky DJ sits by and attempts to muffle his obvious frustration
† Ozzy and Kelly appearing together on *Total Request Live*
† Kelly's mad, rockin' seventeenth birthday party, with a sick, Halloween vibe
† The interaction between Jack and the cute brunette girl who sleeps over in his room after the birthday party
† Kelly showing Ozzy her new tattoo of a heart on her hip (which all her friends also got)

Before the party itself, Kelly's best friend, Robert, gives her a bagful of pink gifts, including a rose quartz bracelet. Ozzy and Sharon transform their home into an elaborate party scene for Kelly's birthday. The Halloween-themed celebration is complete with caterers, entertainers (including a contortionist), and a DJ. Ouija boards serve as centerpieces. Teens come in and out of various rooms of the house, while Ozzy lounges with Sharon on sofa chairs. While the party-goers seem to enjoy the festivities to the fullest, the hardest rocker of them all becomes increasingly agitated by the techno/trance music being played: "It's music to get your brains kicked in to. It's like a four-hour-long record, all the same music, you know?" moans Ozzy.

The morning after the party—or more likely the afternoon, by the time the Osbournes rise—Kelly presses Jack on the fact that he had a girl sleep over, and in typical brotherly fashion, Jack retorts by busting Kelly on her big secret: After the party, she went out and got a tattoo. It's a little heart on her hip—nothing compared to her dad's massive paint jobs—but Ozzy insists she tell her mom nonetheless. At the beauty shop, with cell phone in hand while she has her hair washed, Sharon is enlightened to the fact that her baby girl has stained her body with a tattoo. Ultimately, though, Ozzy backs his daughter up, explaining that the tattoo is not that bad: "I thought she was going to show me a picture of a #$&*ing eagle on her ass . . ."

BAD WORD BOX SCORE

30 4
2 3

Once she heard MTV was going to be taping everything that happened in the Osbournes' household, Melinda knew hers was no ordinary nanny job. "I guess I already knew that," she admits. "From my first day, it was a different kind of a thing."

Born in Melbourne, Australia, Melinda was friends with Aimee, who actually recommended the family's hiring her as Jack and Kelly's nanny. As for experience, she had previously worked for a record company in Australia but says, "When I was younger, I looked after children quite a bit." Children like Jack and Kelly? "Quite honestly, there aren't many kids like them."

Nor interviews like the one she had, which wasn't really an interview at all. "In truth, I was vacationing back home and Sharon called," she remembers. "She asked if I'd come work for them. I said, 'Sure, I'd love to,' and she told me to call when I got back. A few weeks later, I went to the house to hang out with Aimee, and I never left. Eventually, they said, 'We better start paying you,' and that's how it happened."

The job description was simple. "Sharon said, 'You need to make sure Jack gets up in the morning and gets to school, and also Kelly needs to get up,'" she says. In practice, the job was more difficult. "Jack did not want to get up. He'd constantly negotiate for five more minutes, then one more minute, and so on.

"I'm the kind of person who doesn't like to be late," she adds. "But Jack does everything on Jack time."

Her concerns pale next to the good times of being at the Osbournes'. "It's never dull," she explains, "and always unpredictable." Though she has her own apartment, Melinda will occasionally spend the night at the Osbournes', especially if Ozzy and Sharon are away or if they go out for a late supper. "The best part of working for the Osbournes is that I'm never treated like I'm the nanny. They treat me like I'm a part of the family, like I'm contributing to something."

BORN:
June 5, 1977

SIGN:
Gemini

MARRIED:
Yes, on September 1, 2000, to rock-and-roll tour manager Steve Varga

FAVORITE MUSIC:
An Australian band called Something for Kate, Matthew Sweet, Stereophonics, Robbie Williams, and of course, the new Ozzy

FAVORITE MOVIE:
"Kelly and I love *Muriel's Wedding*."

AN AVERAGE DAY:
"To be honest, there is no average day at the Osbournes'. Every day is hectic. And every day is insanely fun."

JOB QUALIFICATIONS:
Great boobs. "You've got jugs that start up here," Sharon said.

MELINDA: "QUITE HONESTLY, THERE AREN'T MANY KIDS LIKE THEM."

MELINDA VARGA † THE NANNY

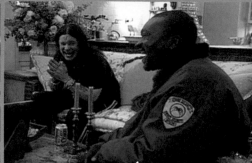
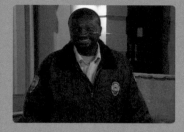

MICHAEL CLARK † THE SECURITY GUARD

AGE: 43 **STATUS:** Married **BIRTHPLACE:** Mississippi

"My name is Michael, and I was hired as security to watch the Ozzy Osbourne and Mrs. Sharon Osbourne house. I walk around the perimeter. I walk outside. I check the front house, the doors and windows, the back house. Make sure just everything is okay around here."

HOW'D YOU GET THE JOB?

I got the job through a security system, and then once I met Sharon and Ozzy, they pulled me in as their personal security guard. The family loved me.

WHAT'D THEY LOVE ABOUT YOU?

My personality. The way I carried myself. I used to show the kids how to shoot pool. I set an example to the kids and their friends.

WHAT WERE YOUR QUALIFICATIONS?

Oh, I'd worked as a security guard for about a year and a half. Before that, I worked at a warehouse. In shipping and receiving.

WHAT WAS THE JOB INTERVIEW WITH OZZY AND SHARON LIKE?

Oh, it was real fun. Mainly it was us talking about stuff over in England, talking about TV shows . . . you know, I was sitting down with Ozzy watching the Jay Leno show. And we watched a lot of movies together.

BEFORE WATCHING MOVIES AND PLAYING POOL, DID YOU HAVE TIME TO PATROL THE HOUSE?

Yeah, sure. I went on a regular basis. You know, I made sure the coyotes didn't come in the yard and mess with the little dogs, and make sure no one gets in who isn't supposed to be there.

DID ANYONE EVER TRY?

Yeah, a few times. I had a guy come in there once. He tried to hop the gate. But the gate almost collapsed on him. That was before they moved in. A few other times, two ladies who I introduced to the family, they tried to get in to see what was going on with all the lights. And of course, the next-door neighbor—that's the lady who ruined everything.

WHAT HAPPENED THERE?

She said that I had broken into her granddaddy's house, or her granddaddy came around and pointed to me and my son as people who'd broken into a house. That led to a little mishap with me and the police, so they took me down to the station for about an hour or two, and then they let me go. I went back to the Osbournes' and told Melinda that everything was all right, that they had the wrong person.

DID THAT LEAD YOU TO GET FIRED?

Yes. But I really never did get a chance to talk to Sharon. She was busy. When all this happened, they were in New York. It was around Ozzy's birthday.

DID YOU FEEL BAD LEAVING?

Yeah. They were all my friends. All the MTV people. They were pulling for me to come back. All the neighbors. I used to talk to the lady across the street, Jack the guitar player, Louie Anderson when he was on his walk . . . the whole neighborhood. They all knew me.

WERE YOU INVOLVED IN THE BREAK-IN?

No, definitely not. Even the police said it was a mistake.

DID YOU FEEL LIKE THE NEIGHBOR WAS OUT TO GET YOU?

I guess so. She had a thing with us. She couldn't get along with Ozzy and the family. I was going to file a suit because they violated my civil rights, but I didn't do it.

IF YOU HAD SEEN AN INTRUDER, WHAT WOULD YOU HAVE DONE?

I would've apprehended him. I had a walkie-talkie and would've used it to call the authorities.

DID YOU CARRY A GUN?

No, sir. I didn't need one. I knew everyone around. I knew Jack's and Kelly's friends. I knew who to let in and who to keep out.

HOW LONG DID YOU WORK THERE FOR?

I think it was close to a year.

WHAT WAS THE SCARIEST THING THAT HAPPENED WHILE YOU WERE ON THE JOB?

When that one coyote came to attack me. I was talking to some of the guys who built the place, and after the conversation, it was time for them to leave. Something told me to move my chair by the garage. As soon as I moved it, a coyote jumped through the bushes. If I'd still be sitting there, he would've jumped on my neck. So I grabbed the shovel, and then when I picked up the shovel he started growling and coming at me. So I put the shovel down and ran through the gates. Once I ran through the gates and didn't pay no more attention to him, he left me alone.

GOSH.

Yeah. And then one night me and Aimee was out there and there were like five of them walking around. I told Aimee to get inside so I could close the gate and let them keep going. They started with me a few times in the backyard, and that's when Ozzy said, "Let me get my freaking shotgun."

WERE YOU THE BEST POOL PLAYER?

Jack had a little friend named Mikey who beat me a few times. Otherwise, I did pretty good.

HOW WAS THE MTV CREW TO WORK WITH?

They were real nice. All of them loved me.

HAD YOU HEARD OF OZZY BEFORE YOU STARTED WORKING FOR HIM?

Yeah, back in the 1970s and '80s. Black Sabbath. I used to live in Costa Mesa with some white folks, and they always played Led Zeppelin, Pink Floyd, Sabbath . . .

WHAT'D YOU THINK ABOUT OZZY?

He's a great guy, a real nice guy.

WHAT'S YOUR FAVORITE MUSIC?

I like Ozzy, of course. But there's a whole lot of them. I like Mystikal, Madonna, but there's so many of them. I listen to all music. Country, R&B, rap. Everything. Pop and rock.

HAVE YOU WATCHED THE SHOW?

All the time. I think it was hilarious. Every time I saw myself, I was kind of shocked.

HAVE YOU BEEN RECOGNIZED?

Oh yeah. Just last week I was working on the Hyundai lot, and these two young ladies came up and said, "You're the guy from *The Osbournes.* The security guard." They asked me for my autograph. I've signed like three hundred or some autographs.

DO YOU THINK WINONA RYDER IS GUILTY OR INNOCENT?

I think she might be innocent. She could be innocent. If she wasn't in her right state of mind . . . I mean, she probably paid for some of the stuff. They say she got caught with, what, about five thousand dollars' worth of items. If she was on medication, she wasn't in her right state of mind, and she should just say that and get on with her life. People will understand.

WHAT ABOUT O. J. SIMPSON—GUILTY OR INNOCENT?

Well, he might know something, but I don't think one person did that.

WHERE ARE YOU WORKING NOW?

I'm working at Nissan of Long Beach, and we got the lot in Carson and Hyundai and Daewoo. We're doing car-lot washes and details.

ANY PARTING WORDS?

Yeah. That I love the Osbournes, and I would like to come back aboard if they would have me. Or let me take a few of my friends to OZZfest. I still love them. I wish them all the best.

DO YOU STILL KNOW THE SECRET PASSWORD AT THE GATE?

Uh-huh. But just in case, tell me, what's the password?

I DON'T KNOW.

There ain't no password. All I have to do is tell them my name is Michael.

MICHAEL:
"I USED TO SHOW THE KIDS HOW TO SHOOT POOL. I SET AN EXAMPLE TO THE KIDS AND THEIR FRIENDS."

Episode Guide #4
Won't You Be My Neighbor

The Osbourne women are angry. Kelly goes ballistic when her older sister, Aimee, books Kelly a gynecologist appointment without her prior knowledge. Ozzy says he'd welcome a gyno appointment. "I won't mind. . . . I'll go for you, cause I feel like a #$&*." Curious, Ozzy asks if his daughter has "been doing anything wrong" or "messing around with boys." Grossed out by talking sex with her dad, Kelly denies having had any sexual encounters with boys. But this doesn't stop Ozzy from going into alpha-male mode to protect his little girl. In fact, he doesn't really believe that Kelly is telling him the complete truth ("There's more to this story than meets the eye. . . . Whenever I mention a vagina doctor, you get a smirk on your face!"). Jack asks his dad if he'd been laid by the time he was Kelly's age, only to get the response of a true rock star. "I was laid by the time I was #$&*ing twelve," he replies.

KELLY: "MY TEETH, MY CAR, MY VAGINA, ARE MY BUSINESS!"

Sequence #2:
THE WICKED WITCH HAS GOT NOTHING ON ME, SWEETHEART!

THE PARTICIPANTS:

PAT BOONE

The Best Human Being Ever?

Not only is Pat Boone the best neighbor ever, or so say the Osbournes, he might simply be the best human being ever. If not, he's a good candidate. Take a look at some facts that support such a claim about the legendary entertainer:

- He was high school class president.
- He married his high school sweetheart, Shirley Foley, in 1953. Still married, they have four children and fifteen grandchildren.
- He graduated magna cum laude from Columbia University.
- He has been a hit in music, television, and film and is a best-selling author.
- He helped found the American Basketball Association.
- He is a direct descendant of Daniel Boone.
- He recorded *In a Metal Mood*, an album of covers of heavy-metal classics, including Ozzy's "Crazy Train."
- He moved to another house in Beverly Hills in 2001.
- He has said that he regrets never inviting Ozzy, Sharon, Aimee, Kelly, and Jack over for dinner. "I miss them terribly."

Meanwhile, Sharon is driven to wit's end by terrible "middle-aged" music coming from the neighbors until all hours of the night. She and Jack debate calling the police, but instead they blast Black Sabbath tunes. "You want to hear some Black Sabbath?" Sharon screams through the hedge between their properties. "You said you wanted to beat up Ozzy Osbourne. . . . The door is open. Come on! Come on, come over, big boy!"

The next day, Ozzy seems oblivious to the previous night's fracas as he shuffles through mundane household chores. But come nightfall, when the neighbors start up their music, Ozzy gets as fired up as everyone else in the family. " I'll throw pig's guts and things over there," he declares. "If they party tonight, war's on!"

They do—and it is. After the neighbors start a mild sing-along of "My Girl," Jack blasts Norwegian death metal. The neighbors yell back. Jack fires a ham-and-bagel sandwich into their yard. And the cops arrive. Although the Osbournes promise the officers that they'll tone it down, Ozzy is about to throw a chunk of wood when Sharon offers a bowl of fruit and baguettes. Is that really a ham he throws?

POLICE: "JUST DON'T THROW BAGELS AT THEM. DON'T THROW CHEESE AT THEM. DON'T ACKNOWLEDGE IT AT ALL. JUST CALL US, IMMEDIATELY."

BEST LINES

† **Kelly's** response to Aimee's booking her a gynecologist appointment: "I'm like 'Aimee, my teeth, my car, my vagina, are my business!'"

† **Kelly:** They were making fun of Dad. They said you [Sharon] were a crazy whore.
 Sharon: Well, they're right with that one.

† **Sharon** (in response to the neighbors' calling her the Wicked Witch of the West): "The Wicked Witch has got nothing on me, sweetheart!" *(Sequence #2)*

† **Kelly:** "The valet guy farted in my car! It smelled ungodly."

† **Sharon** (to the police): You want to hear "Kum Ba Ya" again—the acoustic set? Just hang here, and they'll do "Kum Ba Ya" again, all outside.
 Police: Just don't throw bagels at them. Don't throw cheese at them. Don't acknowledge it at all. Just call us, immediately.

† **Sharon** (to the neighbors): "When you come over tomorrow, please come in. And as your wife said, the big crosses on the door, they're everywhere. We're very religious. So you can catch us before we go to church. Church service is at one P.M., so if you could come at noon, it would be perfect. See you at noon."

HIGHLIGHTS

† Sharon farts on Jack's bear when she is hanging out in his bedroom.
† The war with the noisy neighbors begins.

BAD WORD BOX SCORE

17 14
15 15

YOU'VE TRAINED OTHER CELEBRITIES. HOW DOES OZZY COMPARE?

He's an animal. Well, he's eaten animals, that's for sure. Ha—yeah, and that would be the protein on his diet. But I'm talking about his workout. Man, the guy is pure animal, totally amazing.

HOW LONG HAVE YOU BEEN WORKING WITH OZZY?

We go back now about a year and a half.

HOW'D YOU GET STARTED?

I was training Jack, and Ozzy would jump into the room and in a real endearing, fatherly way tell me to kick Jack's ass and make sure he didn't have enough strength to go out at night and wander the streets.

AND DID YOU?

That's not my style, which is what eventually brought Ozzy to me. One day Ozzy told me that the last trainer he'd had tried to kill him by driving him into the ground. I told him I didn't work that way and to let me know anytime he wanted me to train him. Then Jack started to push him to work with me because he was in constant pain with his back and hips. "Hey, listen, I'm seeing Jack at noon. Why don't I spend time with you after?" He said okay.

WHAT'D YOU DO THAT FIRST SESSION?

I took him through some basic postures, some basic alignment movements. Most important, I suggested he get out of the slippers he shuffled around in and put on some supportive sneakers. That slight change convinced him that I knew something about fitness.

WHAT DO YOU DO FOR OZZY?

I do a lot of alignment work with Ozzy because of his poor alignment and posture, and that's really the prescription for his feeling good. What I've done with Ozzy is just stretch and strengthen his muscles. When he's on the road, he still feels good. I take Ozzy and make him better, make him stronger.

WHAT KIND OF SHAPE IS OZZY IN?

He can sit on a stationary bike for four hours. If he gets into a zone, he'll stay on till he falls off. He's an athletic guy. To do what he does onstage takes strength and endurance. Just because he doesn't have a football or a bat in his hand doesn't mean he's not athletic. Honestly, given all he's been through, Ozzy is in amazing shape. Heck, just being upright is amazing. Don't ever underestimate this guy. He had good endurance before I got to him, but

during the past year he's achieved a nice chiseled physique. Ozzy likes to wear a sleeveless shirt onstage and sometimes he'll rip it off, and your attention is naturally drawn to his tattoos, so we worked on defining his shoulders and arms. Also his midsection.

WHAT'S A TYPICAL WORKOUT LIKE?

We train anywhere from sixty to seventy minutes. I start Ozzy off by cooling him out, almost like a meditation process. Although Ozzy might have been home all day prior to my arrival, he has a million things going on in his mind. So I do a meditation—like stretch him on his back. He breathes, relaxes, and stretches. Then from there we start to get aggressive. I'll take him from that supine position and then warm up the middle of his body. So we've done a twenty-minute warm-up before he's moved a muscle. Then he gets on his feet and does some air-body movements, working all the muscles without any resistance. We shadowbox. We do a bicep crawl. It really wakes him up. Finally, when we hit the workout portion, Ozzy is fired up. He's ready. He's into it. That's when I add resistance—barbell, dumbbells, all the while incorporating some high-step-cardio movements of mine.

HOW IS HE AT THE END OF THE WORKOUT?

It's one of those bittersweet feelings where, wow, he's exhausted but he feels exceptional.

HE DOES LOOK GREAT.

Thanks. I've basically taken a wild animal and made him ferocious—in a very sexy way.

WHAT DO YOU TELL HIM IN TERMS OF NUTRITION?

That's sixty percent of his feeling good. You can have someone in the gym seven days a week, and if they aren't eating and hydrating properly they aren't going to feel good. Ozzy is very conscious of the way he looks, and he has a tendency to put on weight. So I like him to eat more proteins than carbohydrates or fat grams. It's not about losing weight but maintaining the weight loss—that's where the success is. Most people eat all they can of everything they can. While they're eating lunch, they talk about where they're going to eat dinner. But as I told Ozzy, the key is to eat when he feels hungry and to quit the moment he no longer feels it.

SO BASICALLY IT'S DOVE HEAD HERE AND A GLASS OF OX BLOOD THERE?

Very funny. A meal to Ozzy is no longer when you sit down and look at multiple things on a plate. Nor is it biting the head off a bat, though that's a good-sized portion. I have him grazing throughout the day. A meal to Ozzy can be two bites of a chicken breast or half an apple, and then he moves on. Ozzy eats from five to eight times a day. But small meals, so his metabolism is effective all day long. He is revved up and ready to go.

PETE:
"I KNOW PEOPLE THINK IT'S ALL ABOUT FANCY CARS, BIG HOMES, JEWELRY, BUT I DON'T KNOW ANYONE WHO DOESN'T WANT TO KNOW HOW TO GET BETTER ABS AND A SMALLER ASS."

JOB:
Personal trainer, president of Better Shape-Up

OTHER CELEBRITIES HE'S TRAINED:
Larry David, Glenn Frey, Eddie Money, Patrick Leonard, Alan Alda, Edward James Olmos, Catherine Bach, Marlo Thomas—it goes all over the map.

Ozzy's
DAILY DIET

10:00 A.M.	AN EGG-WHITE OMELET WITH SPINACH OR TOMATOES
12:30 P.M.	FRUIT
3:00 P.M.	SOME CHICKEN BREASTS
5:30 P.M.	MAYBE A PROTEIN BAR
7:30 P.M.	A PIECE OF FISH WITH A VEGETABLE
10:30 P.M.	A COUPLE OF APPLES

JASON DILL † PRO SKATEBOARDER

"Hey, man, it's Jason Dill. I'm calling from a hotel phone in Barcelona, Spain. It's costing me my life's savings. Call me back, okay?"

"Okay." (A minute later, the call is made and Jason picks up the phone.)

"Jason, dude! Do you have a few minutes to talk?"

"I'm here, I'm not drunk—yet. Let's go."

AGE:
25
BIRTHPLACE:
Costa Mesa, California
OCCUPATION:
Professional skateboarder
CLAIM TO FAME:
A friend of Jack's, he was kicked out of the Osbournes' house after staying for a month.
SPONSORS:
Alien Workshop Skateboards, DVS Shoe Co.
INTERVIEW DATE:
July 17, 2002, Barcelona, Spain

START°

OKAY, FOR STARTERS, WHO THE HECK ARE YOU?

#$&*, man. I'm a professional skateboarder, and how I attained that was the area I grew up in, Huntington Beach, California, is kind of like the area where skateboarding came from. There you can either play for the #$&*ing football team or you skate and you surf. That's what I did. I skateboarded.

There were people right down the street from me who ended up being huge skateboarding pros, and they taught me the ranks. Like Jason Lee, who's now an actor, he was a major influence of mine. He lived right down the road for a while. I used to skate with him when I was a young lad. Other than that, I turned professional when I was sixteen.

How you turn pro is when you are younger you enter a bunch of contests that are put on by, like, the California Amateur Skateboard League, and you take really cool pictures with photographers that get in magazines like *Thrasher* or other big skateboard publications. I started doing that. And then people told me I was good—you know, good enough to be a professional skateboarder.

After I turned pro, I started making money out of it, which was sweet, and dropped out of high school, and I started paying my mom's bills. It's been nine years now. It's sweet.

But it #$&*ing sucks when you tell people what you do. I mean, I'm proud of being a pro skateboarder, but pro skateboarders are #$&*ing knobs. They're such dorks. Pro surfers are dorks, too. And so are pro snowboarders.

WHAT DO YOU MEAN?

If I meet a girl, and I meet her parents, which doesn't happen much, but you know, I sometimes meet a girl's parents, and then I say I'm a professional skateboarder, they're like, "What? What's a pro skateboarder? What kind of #$&*ing knob life are you living?" Even though I'm like #$&*ing well beyond their tax bracket, it's like they look at me as, "You d**k, what's my daughter doing with such a loser?"

HOW'S THE MONEY?

Right now it's huge, ridiculous. Sometimes I get checks and just go holy #$&*. I mean, I'd love to be making more. I have a money manager and a tax attorney and all that, but, like, I'm not too frugal. I'm kind of living like a twenty-five-year-old who was told he only has a couple years to live.

WHAT'S YOUR LIFESTYLE LIKE?

The lifestyle right now is—well, I moved to New York about four or four and a half years ago. I bet you heard that a couple buildings fell down in New York. After that, the landlords of the place where we were living raised the rent on us, like, whatever. I cut that place off. We moved, like, three months after that. And now my present situation is this: I told all my sponsors I'm not going to live anyplace and instead just do these skateboard tours and videos.

WHERE ARE YOU NOW?

Right now, at the moment, I'm in Barcelona making a skateboard film, one of those cool #$&*ing skateboard videos that kids buy. Before this, I was in L.A. for a while and filmed a bunch of stuff out there and dislocated my shoulder and then I went on a crazy drinking spree, going ape-#$&*, going wild, all over L.A.

Then I cut that out and went to New York, where I went ape-#$&* again. Then I went to Portugal to see this girl, this friend of mine named Dion, who was vacationing there. She's from Australia and real, real sexy. Had a great time. Got drunk. Crashed on a scooter. It was amazing.

Then I flew to Omaha, Nebraska, and hooked up with the third leg of the U.S. skateboard tour where kids show up and get your autograph and $%&#, and they get all stoked. That ended in Detroit. Then I flew to London, where I spent a little time filming some tricks in the streets—real artsy street skating. Then I went from London to Scotland, back to London to Paris, which was exceptionally great because I just #$&*ing drank, went to clubs, and all the stuff that makes life good.

WHAT A LIFE! I DON'T GET WHY YOU'RE EMBARRASSED TO TELL YOUR GIRLFRIENDS' PARENTS THAT YOU'RE A PROFESSIONAL SKATEBOARDER.

It's fun, but would you want your daughter bringing me home?

YEAH, I SEE WHAT YOU MEAN. WHAT ABOUT DRUGS? DO YOU DO THEM?

Just pharmaceuticals. Otherwise, I'm drug free. Know why? I think I've done too much of it. I mean, I used to smoke so much #$&*ing weed it would make your head spin. It made mine spin. It was ridiculous. It's all I did. It's a stupefier. It just makes you forget. But I drink a little. Hell, I drink a ton. I'm open about it now. It's better that way. Except so far today I've only had one beer. But hey, I'll tell you what. Last night I got #$&*-faced.

WHAT MUSIC DOES A DRUG-FREE GUY LIKE YOU PREFER?

Favorite music? Man, what a dorky question. I hate questions like this. You know, like, if I had to pick five albums to take to a deserted island? I don't know. Most music sucks. I love Radiohead, though. I really love Radiohead. To me, they're so off the charts. Everything they do is so different and strange. I also like Bowie, of course. Beatles. Beach Boys. All that #$&*.

JUST TO PROVE YOU'RE NOT A TOTAL KNOBHEAD, DO YOU HAVE A FAVORITE BOOK OR AUTHOR?

I like Burroughs a lot. William S. Burroughs. Let me save you the time and ask the next question. What's my favorite Burroughs book? *Junky*. That's my favorite Burroughs book. That book is great.

HAVE YOU READ DENIS JOHNSON'S *JESUS' SON*?

No, but I saw the movie. The one with that hunk dude in it. Crudup. I also love Bukowski. Nothing's better than Bukowski and a beer. A couple of beers.

One of my brothers bought me *On the Road*, a coming-of-age book, when I was, like, fourteen or fifteen. I started to read it and went, "What the #$&* is this?" I'm sure Jack Kerouac is a great writer, but I tried to read him again recently because everyone said he's great and I thought I should see what's so great about him. So I get this book *Tristessa*. He's in Mexico City, he's talking about this beautiful girl he's with, he's talking about her cheekbones, the lamp shade, and a chicken running around . . . I'm thinking, man, what are you talking about a girl's cheekbones for? Where's the #$&*ing sex? You take me all this way and there's no pulse.

WHAT'S YOUR FAVORITE TV SHOW?

$%&*, the only thing worth watching is—right now I'm in a hotel room in Spain and the only thing to watch is CNN, and what does it tell you? That people are assholes. Aren't people assholes? Ah, the only thing worth watching on TV is *The Simpsons*.

WHAT ABOUT *THE OSBOURNES*?

It's a great show. I love watching it. I think it's #$&*ing hilarious. However, I was absolutely #$&*ing scared to death right before that episode was coming on, I'll tell you that.

WHY?

I knew I was such a #$&*bag the whole time I was there. You know?

HOW'D YOU END UP AT THE OSBOURNES'?

My roommate, this guy I don't live with anymore but he's still one of my best friends—Mikey—he's known Jack and Kelly for a long time. He'd met Jack at the Roxy or On the Rox, I don't remember which but they're right on top of each other, so what does it matter? And when they'd come to New York, we'd go to clubs and #$&*t. So when we'd go to L.A., we'd hang out. It started like that, and we always kept in contact.

Okay, so then I was in L.A. last year, it was around Christmastime. I was with my girlfriend. We'd been going out for about a year, but #$&*, it was so lame at the time, she was over it and I was over it. So we broke up.

I booked myself a hotel room on Sunset right down from where they lived. But Jack said "Come stay with me." I said, "Oh man, no, I don't want to be a bother. Besides, I should be doing work." He said, "No, come stay with me." I said, "No, your mom is going to be bummed seeing me around." He said, "No, no, no, it's totally cool."

And it was cool. But hey, a month, man. I stayed a whole #$&*ing month, and a month is, what, it's, like, a month. Eventually I realized I was just an enormous pain in the ass-type leech, and I was, like, Jeez, come on, you're a twenty-five-year-old dirtbag, get ahold of yourself and stop being drunk in their house and smoking cigarettes all the time.

WHAT DID YOU THINK OF OZZY?

Ozzy is funny. He's real quirky. You'd think he'd be, like, so whatever, so out of it. But he's pretty quick. He blew me away.

HOW SO?

He watches the History Channel all the time. So the only conversation we really had is one time we were talking about the St. Valentine's Day murders when a gangster dressed up like a cop and shot all these dudes. And before the show actually started, Ozzy rattled off the date and year it happened, and sure enough, then the show came on and Ozzy, man, was right on the money. I thought, man, this guy's a total #$&*ing gourd.

HOW ABOUT SHARON?

Sharon treated me like a son. That's the one thing I wish they'd really showed. Sharon treated me like her own flesh and blood. She still is to this day so awesome. I mean, recently, I was living at this house in L.A. where Mikey is living, and she gave us a big-screen TV. I said, "Why are you giving us a big-ass TV?" and she said, "Oh, we're not using it." She also asked me if I wanted to go to Hawaii with them. How awesome is that? Of course, I turned her down because if I ever get a favor from Sharon Osbourne, it's going to be a job, not a flight to Hawaii.

WHAT HAPPENED THAT WE DIDN'T SEE? ANYTHING INTERESTING?

Naw, but I think MTV wanted to show me as just such a dirtbag. It's pretty funny if you think about it. Like #$%*ing Ozzy Osbourne and his family and some dude living with them, and they wanted to make it seem as if I really didn't give two #$&*s of a #$&*.

Here's something: One day I went and stayed at my friend Jordie's house instead of staying at the Osbournes', and when I came home in the morning, Sharon was like, "Oh my God, where were you? I didn't know you were going to leave. You should've told me."

Other than that, there were a lot of times when Kelly and Jack and I would come back after being at a club or a bar, and Sharon would stay up late and talk to them and, like, Sharon would come into Jack's room and sit on the bed and talk.

But the thing they didn't show—they didn't show enough of how Sharon and Ozzy at the end of the day were mother and father, as much as they could be normal parents. Look, you're a #$&*ing rock star. You're the godfather of heavy metal. Of course you're going to have #$&*ing psycho kids.

WERE YOU A GOOD HOUSEGUEST?

You saw me clean up my dishes, man. I cleaned my dishes!

DID YOU MAKE YOUR BED?

No, I didn't really have a bed. I slept on Jack's couch.

WERE YOU UPSET ABOUT HAVING TO LEAVE?

No, I'd been there for a month, and we wouldn't do #$&* most of the time. Most of the time I'd be drinking during the day and then go drinking that night. I mean, me and Jack would sleep in till four in the afternoon. It was ridiculous. It was, like, while the cat's away the mice will play. Being up till four in the morning, getting drunk, and at the end of the day we wouldn't have done anything. Let's say it was time for me to leave.

HOW'S THE FOOD THERE?

It was #$&*ing great. Ozzy eats Koo Koo Roo every night. He always had a bunch leftover. He ordered way too much of it.

DID YOU EVER FIND OUT WHAT DID HE THINK OF YOU?

I heard he watched the show when he was in Hawaii. Mikey watched it with him. And Ozzy was like, "Man, that kid Dill was really bad." And Mikey was like, "Dude, you don't understand, I owe that kid, like, ten thousand dollars." Ozzy was like, "I know he's your friend, but he's real bad." Mikey said, "Come on, you're Ozzy Osbourne. How bad could he be?"

WHAT SORT OF REACTION HAVE YOU HAD FROM BEING ON THE SHOW?

Look, I'm not a #$&*ing actor, I'm a #$&*ing pro skateboarder. That's it. I'm a twenty-five-year-old with a great occupation. I travel the world and do whatever the #$&* I want without having a high school diploma. That's who I am. Now, as far as the show goes, it's random dirt, loser, dropout, #$&*. It happened spontaneously. Nothing was planned. Nothing. But yes, I was the guy on *The Osbournes*. Who wouldn't want to be the guy?

JASON:
"YOU SAW ME CLEAN UP MY DISHES, MAN. I CLEANED MY DISHES!"

Episode Guide #5
Tour of Duty

The Osbournes go into tour mode. Ozzy prepares to go on his "Merry Mayhem" tour by work-ing out, rehearsing, making a video, and eventually hitting the road. What do the rest of them do? They shop. As Sharon, Kelly, and Kelly's friend leave for the stores, Ozzy waves good-bye and says, "Every shopaholic needs an accomplice."

Sequence #1:
"I'M THE PRINCE OF #$&*ING DARKNESS"

THE PARTICIPANTS:

Or someone to carry their purchases. Jeans, jewelry, purses—by day's end, the Osbournes' SUV is filled with shopping bags. "We cover each other's ass," Sharon says, preparing for Ozzy's reaction. "It's all stuff for your bathroom," Kelly tells her dad as they bring in the booty. Kelly has a wobbler after losing her dad's credit card; then she finds it in her car.

Sharon keeps things moving in preparation for the tour. Ozzy appears in garish drag for a Moulin Rouge–inspired photo shoot. Catching sight of himself in red lipstick and a black bustier, Ozzy cracks, "The things I do to make a #$&*in' living!" After settling in on the tour bus, Ozzy and Sharon reminisce about their travels when the kids were just babies. "You know," Sharon sighs, "we're not the #$&*ing Partridge Family."

There are rehearsals and sound checks, and Ozzy's cool with twisted décor and a heroin-chic Santa decorating the stage. But he doesn't like the bubbles Sharon has ordered. "I don't want to use the #$&*ing bubbles and #$&*ing cannons," he says. "I just want to play rock and roll, man!" He also balks after discovering Sharon has booked back-to-back concerts in separate cities. "I can't do that anymore," he complains and then tells Sharon that it's abuse.

SHARON:
"YOU KNOW, WE'RE NOT THE ＿＿ING PARTRIDGE FAMILY."

START°

1

2

3

4

5

6

7

8

9

10

Sequence #2:
"THE FOLDING CHAIR"

THE PARTICIPANTS:

11

Sequence #3:
LOOKING FOR DADDY'S CREDIT CARD

THE PARTICIPANTS:

BEST LINES

† **Sharon:** "I hate washing up. I hate cooking. I'm never doing it again. Martha Stewart can lick my scrotum."

† **Sharon:** Is that son of ours in bed?
Ozzy: He's just contemplating his next . . .
Sharon: Yeah, his next wank—whether he uses his right hand or his left.
Ozzy: Don't be so disgusting, Sharon.

† **Sharon:** Okay, how can we get Daddy to watch the TV in the playroom? Because it's so loud I can't do anything in the kitchen, and I want to cook . . .
Kelly: Mom, you don't know how to cook!

† **Ozzy:** "Bubbles? Oh come on, Sharon! I'm the Prince of #$&*in' Darkness!"

HIGHLIGHTS

† Kelly and Sharon shopping together with Ozzy's credit card
† Ozzy in drag at the Moulin Rouge–inspired photo shoot
† Following rehearsal, Ozzy's folding chair collapses and he falls backward

BAD WORD BOX SCORE

41 **2**

1 **5**

Family Values

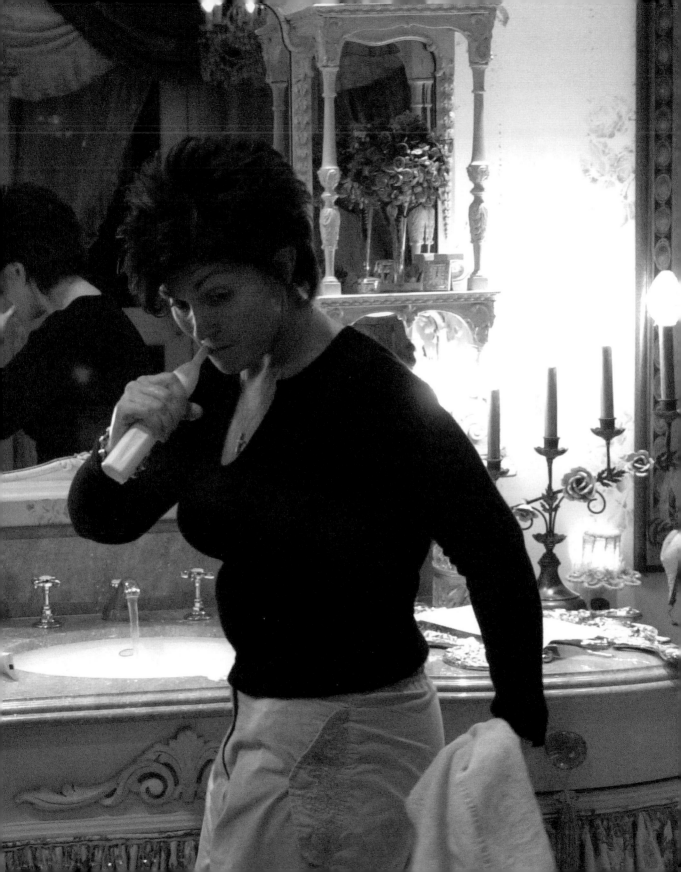

The two teenage children are going out for the night. Before they head out the front door, their father dispenses some advice and rules. It's a classic TV situation, but with a twist. The dad is Ozzy Osbourne. "Please don't go get drunk or get stoned tonight," he tells Kelly and Jack before they leave for to a nightclub. "Because I'm #$&*ing pissed off because I can't. Don't drink. Don't take drugs. Please."

"No, no, I don't do that," Kelly replies. "I don't do that."

"And if you have sex," Ozzy adds, "wear a condom."

You don't just relate to Ozzy and Jack and Kelly, you listen. You've been there. Ozzy's concern rings true. His children's impatience is honest. *The Osbournes* is *Father Knows Best* meets *Behind the Music*. It's real life, rock star-style, and that's only the half of it. This is a family with definite values regarding sex, drugs, and of course rock and roll.

Like other parents, Ozzy and Sharon know their kids are thinking about sex. "That son of ours is contemplating his next wank—whether to use his right hand or his left," Sharon says. And they worry about drug use. "If he smokes a bong, you must tell me," Ozzy says to Melinda, "because he's going to have that #$&*ing thing shoved up his butt."

START°

CURFEW `FAMILY VALUES`

SHARON: Curfew, curfew, false ID, curfew, and school—that's what it's about.

OZZY: Big Daddy is just fed up with the bull#$&*.

SHARON: We have to put our foot down, and that's it. We have to be strong. Look, do you . . . tell me this. Do you think it's right that night after night, you both go out late, you both party, and there's no structure? We've got no structure. We've got to work out a plan.

OZZY: We have to have some kind of agreement about going out, going in. You can't keep funning around town all hours in the week.

SHARON: Look, last night, at two-twenty, somebody drops by to play pool. It's just not normal.

OZZY: I haven't paid all this money for a #$&*ing amusement arcade. I might as well stay in a hotel. Would you be allowed around their house to play pool at two in the morning? I don't think so. If we say . . . what's a reasonable time, Sharon?

SHARON: I think twelve-thirty in the week.

KELLY: I have something to tell you. My thong . . .

SHARON: Your what?

KELLY: . . . is so far up my crack right now I couldn't even pull it out.

SHARON: I'll cut it off. Let me cut it off, Kelly. Kelly, you get yeast infections from that. Do you know that?

KELLY: I've never had a yeast infection, Mom.

SHARON: Well, you #$&*ing will, missus. I don't know how anyone can wear that and think it's comfortable, Kelly.

KELLY: It's not. It's only so you don't see your underwear line.

SHARON: Who cares? I think to see an underwear line is sexy.

KELLY: Mom, Aimee wears a thong every single day, and right now she is wearing a thong of mine. So it's been up my crack, and now it's up her crack, and I'm not down with that.

SHARON: That's insane!

OZZY: That's it then. It's all sorted.

KELLY: "There's usually a two-thirty curfew. They're just like, 'Where have you been? What have you been doing?' And if they believe you, then it's, like, one thing. But if they feel you're lying, which we usually are, then it's, like, you don't really do anything the next day. Just lay low."

WHAT ARE YOUR RULES WHEN IT COMES TO CURFEWS?

SHARON: Did you notice neither of us say a word? We just look at each other. Curfew during the week is midnight, and on the weekend it's two-fifteen to two-thirty A.M., which is when the clubs end.

OZZY: Which I don't approve of, to be honest. I mean, a seventeen- and a sixteen-year-old kid—it's too late for them! But my word doesn't go very far around here.

SHARON: They're night owls, though. It's very hard for them because we're all night owls. They come alive at night. But if they come in late . . .

OZZY: For instance, a week ago on a Thursday I said to Kelly, "You have to come home by sunset tonight because you have tutoring tomorrow." It turns out she doesn't come back [until] God knows how late. [I said], "I'm gonna ground you." What does she do? She sneaks out and gets crazy drunk and she's going to OD on alcohol! To be a parent, especially to rock-and-roll kids—I think being a parent is the most difficult job on the face of the earth. You hate to say things that will upset your kids, but then sometimes you have to, because you can't let them run around wild.

WHAT ARE YOUR OPINIONS OF HOUSE PARTIES—PARTIES YOU KNOW ABOUT AND PARTIES THAT YOU DON'T?

OZZY: You know, we're pretty liberal with our kids. I don't allow smoking of any kind in my house. Jack's been busted a few times smoking a joint, but when I was seventeen, I was the worst kid on the face of the earth. If you wanted me to do something, just tell me not to do it. I'm brutally honest to the kids. I say to them, "If you have sex, wear protection and don't take drugs." The bottom line is that we are guests in America; we're not American citizens. If my kids get busted, we're out of here faster than we can pack a bag.

SHARON: Back to the house party subject, I'd much prefer to have the kids bring their friends here, so I know where they are and what they're doing. And they all have their own sitting rooms and this room [that we're in] is their room, so they can have whoever they want whenever they want, it doesn't bother me.

OZZY: On the whole, every kid screws up. They're not in the army; we don't say, "You must bow down when you see me." They're kids, and they're going to do what kids do. And I keep reiterating that if they get busted for drinking in a public place, they'll get thrown out. But me, I just [say to myself], "What right do I have to say anything when I've come home in police cars and ambulances?"

SHARON: I think a big part of being a parent is to be there when your kids f**k up. You pick them up, dust them off, and try to put them back on the right road. But all kids want to experiment, all kids are gonna break their curfews, that's part of being a kid.

OZZY: We could say, "Okay, you're grounded for a month." And then after two days we go, "Oh #$&*, well, here's the car keys."

SHARON: I try to treat them as young adults and hope they'll give me back the respect, so if they want to stay out later than curfew then they're not afraid of picking up the phone to say, "Look, this is what's going on, this is where I want to go, can I go?" Instead of, like, being afraid to pick up the phone and call.

OZZY: The bad thing about breaking a curfew is that Sharon won't go to sleep until the last one's in [for the night]. When you have kids, no one gives you a book and goes, "Here's a book, read it, it will help you along the way."

SHARON: Everybody is different; every child is different. There is

no way I can sleep until they're home.

OZZY: For instance, Jack comes in, and he's all bubbly and sparkly. Sharon comes in and goes, "How much have you drunk tonight?" and he says, "Mom, I've had nothing to drink, I swear." Sharon says, "Okay," and lets him carry on for another five minutes. Then she says, "Okay, Jack, how many beers have you had tonight?" He says, "Okay, Mom, *two* beers." She lets him carry on talking, and she says, "Are you sure it's just two beers?" and he says, "Okay, Mom, it's been four beers . . . one vodka." The next time she asked him, it's five beers and four vodkas. She's like, "Okay, go to bed." To try to pull one over Sharon's eyes is [silly]; we've been there, done it ourselves—that's what our kids seem to forget.

SHARON: And the thing is that no one knows you like your mother. They come in, and I can tell by their faces exactly what they've been doing.

SEX FAMILY VALUES

HAVE YOU HAD THE SEX TALK WITH KELLY AND JACK, AND HOW DID THAT GO?

OZZY: When I was a kid, my father told me nothing about nothing. So what I learned was off the street. So what I say to my kids is that you might not want to hear it, but this is how it goes: If you have sex, use a condom. They say, "Oh, Dad!" and I say, "I don't care, I've told you." I'm not going to go, "Here's a little pamphlet, go through it!"

SHARON: I have [had the sex talk]. I've gone through it all with the girls. I've talked about everything. And all you can do is advise them because they're ultimately going to find out the way we all did. You don't think you're going to do it, and then you end up doing it. And especially for girls, their first time is usually horrible. I mean, I can remember back to when I was a kid, when I first did it, I hated it. And it always seems that the guys end up having a better time than the girls. I always tell the girls that the greatest gift you can give anyone that you love is your body. It's the greatest gift, and it's special. And as much as you think you love someone, it's puppy love, it's infatuation, and you've got to take your time, take little steps in regards to men. It's something so special to give away. It's the ultimate gift to give someone. And I try to make them realize how special they are just by being a woman. All women are special. And the same with Jack. Sure, there's tons of girls that want to go with Jack because of who Jack is. He can have sex whenever he wants, he can get a b*** j** whenever he wants or whatever he wants. What I try to tell Jack is to just have respect for that woman because she's a woman like your mom, like your sisters. And have respect, don't go around bragging.

OZZY: But that's what men do.

SHARON: I know, but no one taught you about respecting a woman, not that you don't, because you do. But the thing is that I think that if you instill it into young boys, they will take it in, digest it. If some girl wants to give herself to Jack, he's a guy! Guys live for sex, women want love. The thing is, they'll take it. So take it, Jack, if she's willing to give it to you. But wear protection and don't boast about it and be respectful.

ARE THEY COMFORTABLE TALKING ABOUT IT WITH YOU?

SHARON: If people are around, they're like, "Oh, don't," but one-to-one we talk about it a lot.

SCHOOL FAMILY VALUES

WHAT ARE YOUR RULES ABOUT TEST GRADES AND HOMEWORK?

SHARON: As far as failing a test goes, as far as I'm concerned—I'm not sure what Ozzy thinks about it—but I just want them to try their best. If they go in there and fail, I don't care as long as they've tried. If they go in there and waste people's time, and their time and their effort, it's ridiculous. And I don't care if they fail if they tried or if they're a B-student or C-student. It doesn't bother me at all, as long as I know they've tried their best. That's all you can do. I've never been one of those mothers that say, "My child has to be an A-student." I don't agree with putting that kind of pressure on a child. I believe that you are born clever or you're not. You're either academic or you're not. I hate the pressure, and I hate the competitiveness, like you've got to be number one—it's like, no way! If they have the ability, then don't waste it, go for it. But if you put pressure on someone that can't deliver, then I think it's really a bad thing to do. A lot of kids are put under pressure to turn in A's and B's, and some kids just can't do it. Everyone is good at something, you just have to find your niche in life that you're good at. It doesn't mean that it has to be algebra or biology or geography.

OZZY: Sharon does all that sort of work. When I was at school they never recognized dyslexia or attention deficit disorder, which we all have—but Sharon doesn't. So my kids have inherited that [from me]. When I was a kid I used to just clown around, get in trouble a lot because I would stare at the blackboard and I wouldn't understand what the #$&* the teacher was writing. It just didn't make sense, like writing in Chinese. Since then, education's come a long way, and I think Sharon's done a remarkable job.

SHARON: It's like a lot of their friends—you know, you've always got a set of friends that are really bright. And a lot of their friends are applying to go to Harvard and Oxford, the best universities in the world, and it's fantastic for them that they're A-students and they can get scholarships. We'll never get scholarships, but they're good at other things.

OZZY [interrupts]: They're good at being people. We do have a laugh in our house sometimes.

FATHER KNOWS BEST

As a kid, Ozzy was guided by a rebellious spirit. He did the opposite of whatever his parents said. "The hardest job in the world is to be a parent," he says. "I think I'm a good parent." His approach seems to work—at least for him.

† GIVE THEM A LOT OF LOVE AND A LOT OF AFFECTION.

† SPEND SOME TIME WITH THEM.

† BE AS HONEST AS YOU CAN WITH THEM.

† DON'T TALK TO THEM LIKE BABIES. THEY'RE LITTLE PEOPLE. I #$&*ING HATE IT WHEN PEOPLE GO "COOCHY-COOCHY-COO." THE KID ALWAYS LOOKS LIKE, "WHAT THE #$&* ARE YOU TAKING ABOUT?"

† HAVE RULES. LIKE, I DON'T ALLOW MY CHILDREN TO LEAVE THEIR CLOTHES LYING AROUND. IF THEY DO, WHERE AM I GOING TO LEAVE MINE?

† DON'T BE RUDE. THERE'S NO #$&*ING EXCUSE FOR THAT #$&*.

† MAKE THEM READ THE INSTRUCTIONS TO THE TV REMOTE CONTROL SO THEY CAN SHOW YOU HOW THE #$&* IT WORKS.

SHARON: The most important thing to me is that you learn in life that you are a good person and you learn to get on with other people. That you learn to be tolerant, all things like that. That's what I care about, not their geometry, not whether they're going to be a doctor or rocket scientist. Although if they were that would be fantastic, I would love them and be behind them. Even if they wanted to work at a garage putting fuel in [cars], I'd be behind them with that, too.

WHAT DO YOU THINK IT IS ABOUT YOUR PARENTING SKILLS THAT HAVE MADE YOUR FAMILY SO SUCCESSFUL?

OZZY: Well, when I was a kid, I'd ask my dad, "Can I have this bottle of water?" And he'd say, "No." And I'd say, "Well, why not?" He'd say, "Because I said so." I think that's such a #$&*ing stupid answer. What we've done—actually, mostly what Sharon's done, because I've been on the road a lot—is explain why they can't have it. For instance, "It's too late to have a Coca-Cola now; you'll be bouncing around the room." So she'll explain why they can't have it. We have a very liberal relationship. My mom used to say, "Wait until your father comes home." Well, that's inflicting fear into your children. We encourage them to be honest, but every kid #$&*ing lies.

SHARON: Every kid bull#$&*s. Every kid will push you to the edge. I think why we get on so well is because we only have us. We don't have an extended family. We do everything together. There are so many families that I know that don't include their children in their social lives and just send them to school. If my kids turned around and said, "I want to go to a university in New York" or whatever, I'd be heartbroken!

CIGARETTES FAMILY VALUES

OZZY: These #$&*ers will kill you faster than crack. Do you know what? I think tobacco is the most addictive #$&* that I ever put in my body. And the funny thing is, you know, you don't cop a buzz.

JACK: You do at first, actually.

OZZY: No, you #$&*ing don't.

Sequence: "SHARON CAN'T SLEEP"

JACK: So I heard.

OZZY: I smoked heavily for forty #$&* years, and I've just quit seven month ago. And I can't stand the smell of the #$&* anymore."

HOW DO FEEL ABOUT HAVING A CURFEW? DO YOU PAY ATTENTION TO IT?

KELLY: I don't pay attention to it, which is really bad. I think it's pretty stupid. I understand why my mom says it, but she comes up with this excuse like, "I can't sleep until [you] get home," and most of the time she's asleep by the time I get home anyway. I understand it's really selfish of me not to listen to what she says, but sometimes when you're having fun and you're not in charge of what goes on—like, for example, this weekend. My brother got completely drunk, and I said, "Jack, we have to go home"—this was at about twelve-thirty at night—and he said, *"No!"* So I go to a restaurant half an hour away from where the club was because I was hungry. So I started eating, and I get this call, "Kelly, come get me! I don't feel well, and I think I'm going to throw up, and I don't want to get in the car because I think they've been drinking and blah blah blah." So I have to get in the car, drive half an hour back to pick him [up], half [an hour] to the house to drop him off, then fifteen minutes back to the restaurant. By the time I ate and got home, it was past curfew, and my mom got really mad at me. I was like, "Look, it's not my fault, Jack did this, this, and this." And then it was my fault because he was drunk. [Mom said], "Why did you let him drink so much, why weren't you watching him?" It's hard trying to explain to my mom that Jack is not my responsibility, and when I try to tell him not to do something, he'll rip me a new $%&*ing asshole. And he embarrasses me in front of his friends. Like, we were out last weekend, and he's hanging out with these disgusting strippers, and I go, "Jack, it's time to go home, we have to go home. It's a quarter to two." And he says, "I didn't come here with you, I don't have to leave with you." And I was just like, "Oh my God, okay, I'm just going to walk away." And all those girls were like, "Why do you have to be such a party pooper, Kelly? What's your problem?" And I'm like, "I don't want my brother hanging out with people like you." I was like, "Get me out of here."

IN ONE EPISODE, WE SEE YOUR DAD TELLING YOU TO USE CONDOMS IF YOU HAVE SEX. DOES THAT TOTALLY GROSS YOU OUT?

KELLY: Ugh! I do *not* need my dad telling me about sex whatsoever! It's, like, not something that a seventeen-year-old girl wants to hear. It's disgusting! It's just, like, I was kind of shocked that he said that. I was like, "Dad, are you promoting your kids' having sex?" [He said], "If you do it, it's okay, just wear a condom." It's just like, "Shut up!"

WHY DO YOU THINK YOUR PARENTS ARE PROUD OF YOU?

KELLY: I think it's because I'm not like the other kids. I'm not easily influenced to do things. If I do things it's because I want to, and I'm prepared to pay the consequences. If you grow up in L.A., you

see some of the kids. . . . For example, when we were little we saw this kid at the mall, and he said, "Mommy, I want a water *now!*" and we were like, "Why is he talking like that?" We were brought up to say, "Mom, can I please have a bottle of water?" We were not brought up to talk to people like that. And here a lot of people talk so rude[ly] to their parents. For example, I have a friend whose mom drove her all the way to the Valley to go to this store to buy eye shadow, and they put the wrong eye shadow in the bag, and when I got to her house she was like, "Oh Mom, you #$&*ing c**t, you got the wrong #$&*ing eye shadow! You're such a failure for a mother! Go back there and get me the right color *now!*" I was like, "How can you talk to your mother like that?" If I say anything, it's "Mom, you're being a bitch," and it doesn't go any farther than that. And it's only out of anger. It's like an everyday [thing] that people talk to their parents like that—my friends do, anyway.

IF YOUR PARENTS WERE YOUR AGE, WOULD YOU HANG OUT WITH THEM?

KELLY: I'd definitely hang out with my mom. I don't know about my dad. I think he'd be too . . . yeah, I think I would, actually. Definitely.

WHAT IS THE MOST EMBARRASSING THING YOUR PARENTS HAVE EVER DONE IN FRONT OF YOUR FRIENDS?

KELLY: It's bad enough that my dad walks around the house in his underwear. There was one time when he was walking around the house, and he just woke up, and his balls were, like, hanging out. I was like, *"Oh my God, get out of here!"* Sometimes my mom flashes my friends—she thinks it's funny to go like this [makes an obscene gesture] and wiggle her tongue around. But some of the things she talks about, I just can't believe it! She's like, "When a girl gets her p***y licked," and she tries to be really funny, and my friends are like, "Oh my God, your mom is really funny!" Meanwhile, I'm, like, crawling up into a little ball and dying.

DO YOU THINK YOUR PARENTS ARE COOLER THEN OTHER PARENTS?

KELLY: Oh, definitely. Because my parents actually talk to me, and they'll listen. Whether they do anything about it is another thing, but they still take the time to talk to me. There are too many parents that don't talk to their kids. And if they do, it's, like, telling them something instead of reasoning with them.

DRUGS FAMILY VALUES

SHARON: Kel, can I just talk to you about the ID?

KELLY: Mom, I will never use it to buy alcohol.

OZZY: How old are you? If you get busted, it's #$&*ing over. Your ass won't even touch the #$&*ing landing strip, man. You're gone, out of here. I don't think that you should be hanging around #$&*ing clubs at sixteen and seventeen—not until you are twenty-one.

KELLY: What you and Dad have to understand is that me and Jack

SHARON:
"IF MY KIDS TURNED AROUND AND SAID, 'I WANT TO GO TO A UNIVERSITY IN NEW YORK' OR WHATEVER, I'D BE HEARTBROKEN!"

have been brought up very differently from everyone else.

SHARON: I know the way you were brought up. I chose for you to be on the road with us so as we could be a family, and I always want us to be a family.

KELLY: It was very hard for me to walk into a classroom every day when I went and be verbally abused or made fun of. They still can't get over the fact, even though it happened twenty years ago, that Dad bit the head off a bat. It's not fair. I don't like it, Mom.

SHARON: That's fine, Kelly, I understand. I was the same. I hated school.

OZZY: Same here.

KELLY: We've all done stupid things, right, but, Mom, I don't do drugs.

OZZY: I'm referring to you, Jack. I will not have dope smoked in my house or drugs at any time at my #$&*ing house. Quit this #$&*ing smoking, because it ain't going to lead to anywhere but bad places. Look at me.

JACK: Everyone thinks I have a problem. I don't drink because I crave it. I don't smoke pot because I crave it. I do it because I choose to do it.

OZZY: Yet. When I started drinking and taking pot, I wasn't addicted yet. But as time goes on, I became very addicted.

JACK: Eighty percent of the population of this country has smoked pot.

OZZY: To me, darling, that's no excuse, because you know what? Ninety percent of the population has a tattoo? Is that to say you've got to have one? Eighty percent of the population poke themselves in the eye every Wednesday. Would you #$&* ing mind doing it?

HOW DO YOU FEEL ABOUT HAVING A CURFEW AND DO YOU PAY ATTENTION TO IT?

JACK: I'm not really bothered by a curfew because our curfew is two-thirty, and after two in L.A., there is nothing to do anyway.

DOES IT GROSS YOU OUT WHEN YOUR PARENTS TALK TO YOU ABOUT SEX?

JACK: To a certain degree, it's just awkward. It doesn't totally gross me out, but no one wants to hear their parents telling you about sex, regardless. It's more awkward than anything.

DO YOU THINK YOUR PARENTS ARE COOLER THAN OTHER PARENTS?

JACK: I don't really know any other parents—just kidding. I think my parents are really cool. Everyone's always like, "Oh, I hate my parents, my parents are assholes, they won't give me twenty dollars." I'm just like, "Shut up." These kids go on about how mean their parents are. I think our parents are really cool.

WHAT'S THE MOST EMBARRASSING THING YOUR PARENTS HAVE EVER DONE IN FRONT OF YOUR FRIENDS?

JACK: My mom has a tendency of flashing. My friend was over at the house one time, sitting in the kitchen. She comes [in], lifts up her shirt, and goes, "Hey, do you think I'm sexy?" to my friend, and I'm like, "Oh, God." And my dad always walks around in his underwear.

WHAT DO YOUR FRIENDS THINK OF YOUR PARENTS?

JACK: I don't know. I've never really asked them. I know a lot of my friends like my parents, some are scared of them, some have never even met them.

ARE THERE ANY RULES THAT DRIVE YOU CRAZY OR CRAMP YOUR STYLE?

JACK: No, my parents are really relaxed when it comes to that.

WHENEVER YOU'RE OUT WITH YOUR FRIENDS, DO YOU EVER THINK, MY PARENTS WILL KILL ME IF I DO THIS OR DO THAT?

JACK: I used to, but not so much anymore. I've done it, and they haven't really cared.

TATTOOS FAMILY VALUES

KELLY: Hello? I got a tattoo.

SHARON: You are joking.

KELLY: No.

SHARON: What did you get?

KELLY: It's really tiny.

SHARON: What is it?

KELLY: A tiny little heart.

SHARON: Where?

KELLY: On my hip.

SHARON: And who did it?

KELLY: Some guy.

SHARON: Oh, that tells me a lot. Would you put your father on?

OZZY: What do you think about that?

SHARON: I think it's . . . I'm so sad.

OZZY: Actually, to be honest with you, it's not that bad. It's a tiny, tiny, little heart on her hip. It's not like a big #$&*ing thing. She's going for that one next week.

KELLY: I just want to know what she said. Is she mad at me?

OZZY: No, she's not mad. She's just very disappointed. She thinks you're a very stupid person.

KELLY: Well, I know that already. I didn't need a tattoo to tell me that.

HOW DOES KELLY FEEL ABOUT HER PARENTS?

"I love them," she says.
DO THEY EVER BUG HER?
"All the time."
ARE THEY TOO STRICT? TOO LENIENT?
"I think they're just right," she says. "We don't have rules," she adds. "We just know what's wrong and what's right."
AND JACK? HOW WOULD HE DESCRIBE THE WAY HE AND HIS PARENTS INTERACT?
"#$&*ing violent."

COME ON, DUDE. BE SERIOUS, DO YOUR FOLKS BUG YOU?
"If you must know," she says, "Mom is way too paranoid, and my dad is also way too paranoid. Both are very, very over protective. So we're bound to have our moments."

TART°

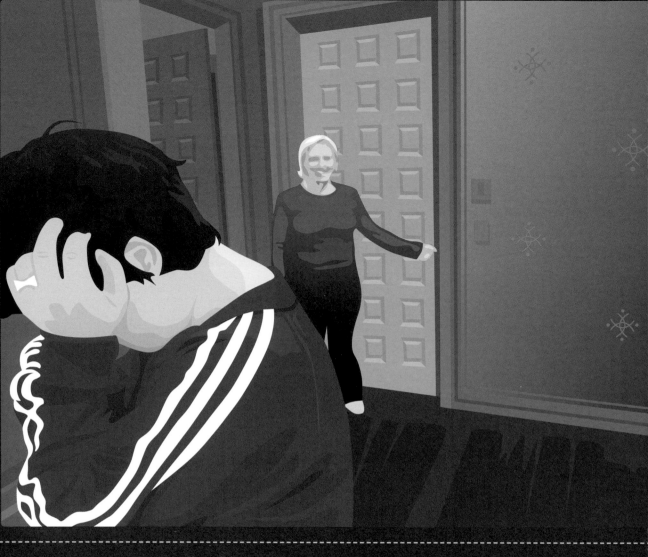

Episode Guide #6
Trouble in Paradise

The Osbournes play, party, and promote. As Ozzy flogs his album ("We're on a whirlwind pro-motion tour," he tells a radio DJ. "We started at six this morning and now it's twelve at night. We haven't stopped for a piss all day!"), his children carouse along the Sunset Strip. Then Kelly fractures her leg tripping outside a club, and Ozzy also breaks his foot while on tour. Jack gets in a heated row with Melinda, and Sharon takes off to be with Ozzy on the road.

Sequence #1: OZZY CHASES PUSS

THE PARTICIPANTS:

JACK:
"EIGHTY PERCENT OF THE POPULATION OF THIS COUNTRY HAS SMOKED POT."

OZZY:
"EIGHTY PERCENT OF THE POPULATION POKE THEM-SELVES IN THE EYE EVERY WEDNESDAY. WOULD YOU ____ING MIND DOING IT?"

Sharon is missed at home, where all hell is allowed to break loose with Melinda in charge. Jack won't get out of bed for school. Then he gets caught smoking pot and staying out long past his curfew. Ozzy demands that Jack apologize to his nanny. "It's a man that can apologize," he says. "It's a wimp that can't."

Speaking of real men, Ozzy does a photo shoot, then goes onstage. Following his exhausting concert, Ozzy's broken foot causes him pain. Needing a few weeks off, he returns home. Sharon asks if his doctor advised keeping his leg elevated. "He said I need to keep a naked lady on top of me for three weeks," Ozzy responds. Later, he limps through the backyard chasing after Puss, the family cat, to save him from being eaten by coyotes.

Kelly defends her use of a fake ID, and Jack plots to attend a rave. Unable to keep track of everyone's busy lives, Ozzy says, "My house is like a revolving door—like a #$&*ing nightclub." Sharon calls a family "meeting" to discuss "curfew, curfew, false IDs, curfew, school," and the kids' overall lack of structure. Kelly defends her social conduct by claiming that life on the road has rendered her more mature and therefore unable to relate fully to kids her own age. Jack flips out when confronted about his pot smoking. Ozzy points to himself as an example of what can happen to someone who's done too many drugs . . . and isn't that enough?

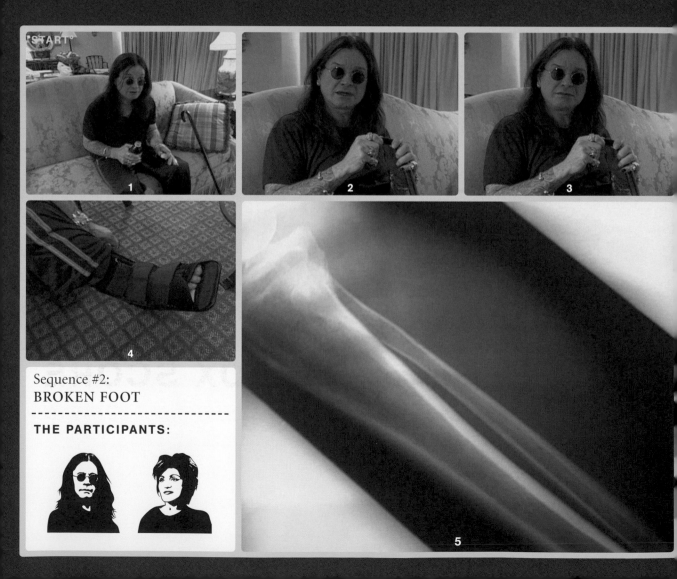

Sequence #2:
BROKEN FOOT

THE PARTICIPANTS:

1

2

3

4

Sequence #3:
JACK VS. MELINDA

THE PARTICIPANTS:

BEST LINES

† **Jack** (talking about Kelly): "She's becoming L.A. trash!"
† **Ozzy** (to Jack): "Don't you think I know what it means when you order a pizza at #$&*ing twelve o'clock at night?!"
† **Sharon** (to Jack as he's partying in the middle of the night): "Just turn it down . . . Jack, the bass is so loud. I'm going to smack your bottom!"
† **Jack:** Eighty percent of the population of this country has smoked pot.
† **Ozzy:** Eighty percent of the population poke themselves in the eye every Wednesday. Would you #$&*ing mind doing it?

HIGHLIGHTS

† Ozzy chasing Puss throughout the backyard
† Melinda trying to get Jack out of bed
† The family meeting

BAD WORD BOX SCORE

55 4

8 2 3

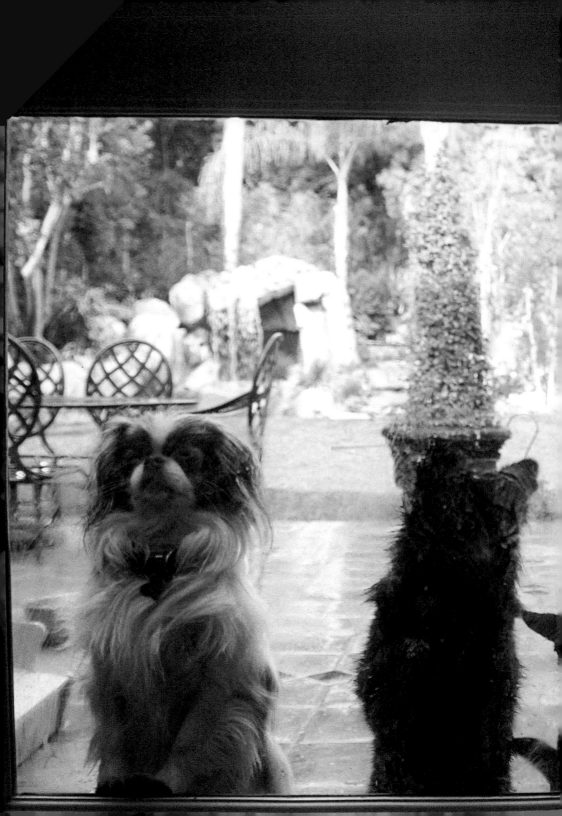

Pets

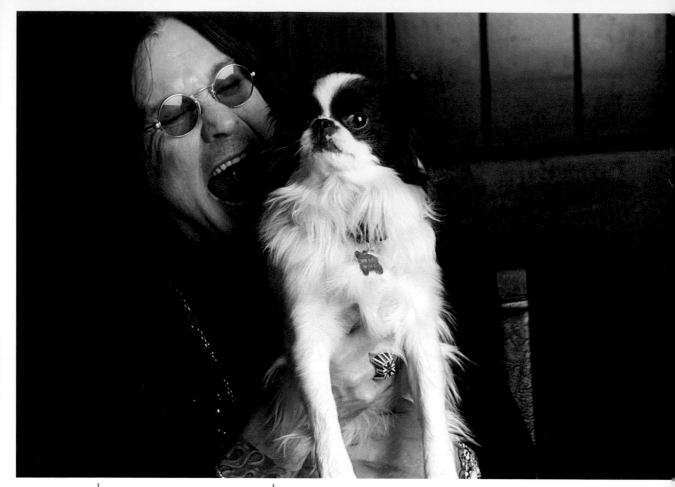

It has been more than twenty years since Ozzy bit the head off a bat, and since then, as *The Osbournes* clearly showed, he has gone to the dogs. So has everyone else in the family. They surely love their pets. The problem is, they aren't trained. Then again, neither are the pets.

OZZY: "I'M BEGGING YOU– PLEASE–NO MORE PETS!"

The Cats

* **PUSS:**
 A "rag doll" with a brown face and feet

* **DIRTY OLD GUS:**
 A "rag doll" that's beige with a gray face, tail, and feet

* **TIGGER:**
 Looks like a mountain cat—ginger-colored with black and brown markings

* **BEVERLY:**
 Jet-black kitten

The Dogs

* **MINNIE, A POMERANIAN, FOUR YEARS OLD:**
 "The top diva in the house is Minnie," says Sharon. That's no surprise. According to the American Kennel Club, Pomeranians are cocky, smart extroverts, possessing big personalities in contrast to their compact build, and Minnie fits the description perfectly. "She rules the roost. Minnie can do anything."
* **MAGGIE, A JAPANESE CHIN:**
 "I call her heroin-chic," says Sharon of this small, aristocratic, distinctly Oriental breed that is described as warm to its companions but shy around strangers.
* **CRAZY BABY, A JAPANESE CHIN:**
 "We changed her name from New Baby to Crazy Baby," says Sharon. "She's a bit neurotic."
* **PIPI, A POMERANIAN:**
 Pipi belongs to Ozzy and Aimee.
* **MARTIN, A CHIHUAHUA** (AKA MARTINI BIANCO):
 "He's totally gay, the gayest dog I've ever seen," says Melinda about the Chihuahua, a mini breed that is always on alert. "He hates women."
* **LULU, A CHIHUAHUA:**
 "She grunts a lot when she's got a very big one," says Sharon. "It looks like a seal."
* **LOLA, AN ENGLISH BULLDOG:**
 Jack's dog—a lovable, big, adorable, typically boisterous bulldog. But Lola is also given to a condition best termed as "uninhibited loose-bowel syndrome." In other words, Lola is the free-spirited pooch responsible for Ozzy's declaring, "They #$&* every #$&*ing where, man." Oops.

If the only discipline a dog needed was love, the Osbournes' pooches would be going outside when they have to go. Instead, the floor is full of land mines, the carpets are spotted, and the furniture is gnawed. Sharon and Kelly sneak in new cats. Jack asks if he can feed Pipi to the coyotes. And Ozzy?

Well, after putting his foot down one too many times where Jack's bulldog, Lola, had previously stopped, Ozzy really put his foot down and declared, "I'm not picking up another turd. I'm a rock star." Lola's penchant for pooping indoors caused Ozzy and Sharon to wonder whether or not there was a boot camp for dogs. No, but if Lola had any chance of remaining at the house, she needed professional help. Enter Tamar Geller, one of L.A.'s top dog trainers.

TAMAR GELLER has to be one of the most attractive dog trainers in L.A. She's also one of the most respected. A former Israeli Intelligence Officer, she developed her unique method of training canines sixteen years ago, after participating in a study of the behavior of wolves. She now owns The Loved Dog Company, a cage-free kennel and doggie day care that is a favorite among Hollywood celebrities.

"I work in the wolf way," she explains. "I do it without a choke chain, without leashes, without screaming commands." Which means what? "I make it fun. Dog training should be a party. That's my philosophy. I want the dog to beg the owner, 'Please, work with me.'"

Given the Osbournes' trouble with Lola's haphazard bathroom habits, you'd think they would've been begging Tamar to work with them. Yet she had no idea what they wanted when she got a call to come to their house.

"Then I got nervous I wouldn't be able to understand Ozzy," she says. "But they assured me that Sharon would translate. So we agreed to do a meet-and-greet to talk about the situation."

Is that the normal type of arrangement?
No. Usually I walk with the clients before I work with their dogs and find out what they want, what their issues are, and what outcome they're hoping to get. But with the Osbournes, I had absolutely no idea what they wanted or even how many dogs they had.

What was your impression upon arriving at their house?
It was a beautiful house. But it was in chaos—organized chaos.

What happened?
They miked me and sent me inside. I went right in. No preparation. When I walked in, I couldn't believe how many dogs they had. It was dogs everywhere. Barking. Jumping. I thought it was a happy situation for the dogs.

What about for the people?
Well, Ozzy didn't say anything. He thought I was a dog psychic or

a dog psychiatrist. He and Jack just sat and mumbled their comments. But Sharon was terrific. The first thing she said—the first thing they all said—was that Lola was the dumbest dog ever born. They said she was retarded. Of course, when I hear something like that, I have to take the dog's side.

Was Lola dumb?

Are you crazy? No, she wasn't dumb. She was a terrific dog. Just working with her a little bit, I could see she was brilliant. She was simply looking for a little bit more instruction from the Osbournes, which is exactly what I wanted to show them.

And did you?

In terms of working with Lola, I told them they needed a little bit more of the S-word, the C-word, and the F-word in their lives— structure, consistency, and fun. Lola is a fun monger. In less than

five minutes, she was responding to basic stuff. She was thriving. Sharon was impressed.

So you had an effect?

How much effect did I have on the dog? A hundred percent. How much effect on the family? I don't know. There's no shortage of fun in their house, but I think they enjoy not having any structure or consistency.

Did you ever go back a second time?

Yes. They asked me to come again. It was right after the holidays. It was a Sunday, and it was raining, and they didn't want to get out of bed. I don't blame them. I waited around for a few minutes, but the film crew warned me, you can't ever predict the Osbournes.

Imagine the effect that would have on their dogs.

My point exactly.

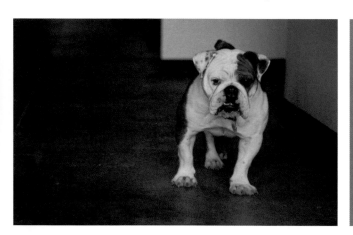

JACK:
"I THINK EVERYONE WAS WAY TOO ING HARD ON LOLA."

OZZY:
"THE OSBOURNE FAMILY IS A GREAT FAMILY FOR WASTING MONEY AND SAYING, 'WELL, MAYBE WE HAVE TOO MANY DOGS AND WE'LL THROW THE CATS IN JUST FOR FUN.'"

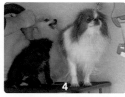

Sequence #1:
DR. DOOLITTLE'S HOUSE

TAMAR:
"THE FIRST THING THEY ALL SAID WAS THAT LOLA WAS THE DUMBEST DOG EVER BORN."

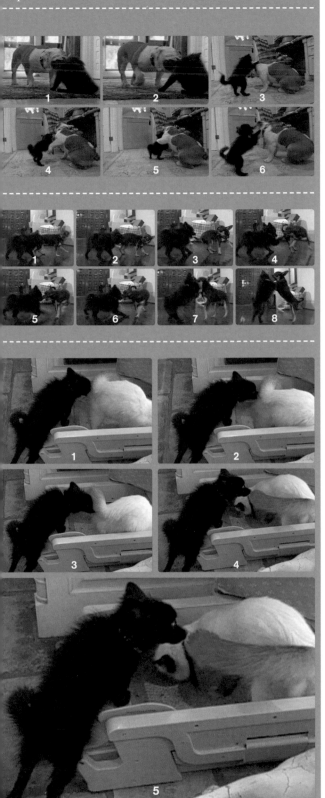

OZZY:
"IT'S LIKE ██ING DR. DOOLITTLE'S ██ING HOUSE HERE ...THE SMELL OF SUCCESS"

OZZY: "WHAT REALLY PISSED ME OFF—WE'VE PAID ALL THIS MONEY TO HAVE THIS HOUSE RENOVATED, AND THE DOGS...YOU MIGHT AS WELL LIVE IN A ██ING CIRCUS. THE DOGS PISS EVERYWHERE."

✝

Episode Guide #7
Get Stuffed

It's Thanksgiving, and the Osbournes sink their teeth into the holiday. It's like any other household. Though he's supposedly sober while on painkillers for his broken foot, Ozzy drinks too much, and the others fight. After Ozzy takes Lola out for a walk, Sharon orders Jack to bring him back. It's a funny sight, seeing Ozzy all tweaked out on booze and holding a glass of wine while playing tug-of-war with the bulldog's leash and standing in the middle of the street.

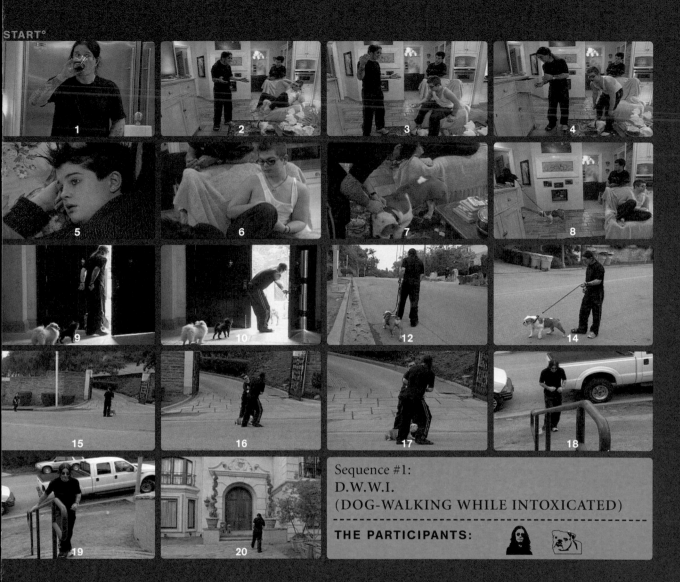

Sequence #1:
D.W.W.I.
(DOG-WALKING WHILE INTOXICATED)
- -
THE PARTICIPANTS:

Rob Zombie directs his video, but Ozzy says no to wearing a bat-themed costume. "I told you before, I don't want anything to do with bats," he tells Sharon. "Is that all my #$&*ing career is about are #$&*ing bats?" Despite the fixes, Ozzy still complains about the way he looks while watching a playback. "This is not good, Sharon, I look like I'm in #$&*ing agony."

Sequence #2:
PLAYBACK

THE
PARTICIPANTS:

OZZY:
"I TOLD YOU BEFORE, I DON'T WANT ANYTHING TO DO WITH BATS."

At home, Kelly complains that she feels like a loser compared to Jack, who, she says, gets more attention because of his deal at Epic Records. According to her, she found the band that got her brother his deal. Ozzy writes her tantrum off as one of her daily wobblers.

Despite his broken foot and his wife wishing Daddy could stay home, Ozzy goes back out on the road. Jack and Kelly are hurt when Sharon says that Ozzy doesn't want them coming out to Chicago for his birthday. It's not that he doesn't love them. He simply doesn't want to spend the money. "I'm out of dough," he says.

But money's no object to Sharon, who takes Jack and Kelly to Chicago and surprises Ozzy on his birthday. Ozzy kills onstage in Chicago, then returns to his hotel and ambles into the restaurant, where he's clearly happy—no, make that deeply touched—at seeing his wife and children waiting for him. What do you get a rock star who has everything? A pooper scooper.

START°

1

2

3

Sequence #3:
ANGER MANAGEMENT

THE PARTICIPANTS:

BEST LINES

† **Ozzy:** "Rule number one: the crazier you go, the crazier Ozzy Osbourne goes!"
† **Kelly:** "We're here in Chicago 'cause it's our dad's birthday on Monday, and he basically told us to #$&* off . . . but we're surprising him."
† **Kelly:** "Jack, you seriously have some anger-management/control problems." *(Sequence #3)*

HIGHLIGHTS

† After stepping in the dog's water bowl for the umpteenth time, Ozzy finally goes to relax and have privacy in his bathroom.
† In the hotel, Kelly and Sharon narrate to the camera. Jack stands in the background, facing the wall, and when asked what he's doing, in a real-life Truman moment, he says, "Hanging out in the background."
† Sharon drops her Valentino mink stole down the toilet. Jack thinks it suits her just fine for buying mink. "It smells like an old crotch."

BAD WORD BOX SCORE

36 11

6 4

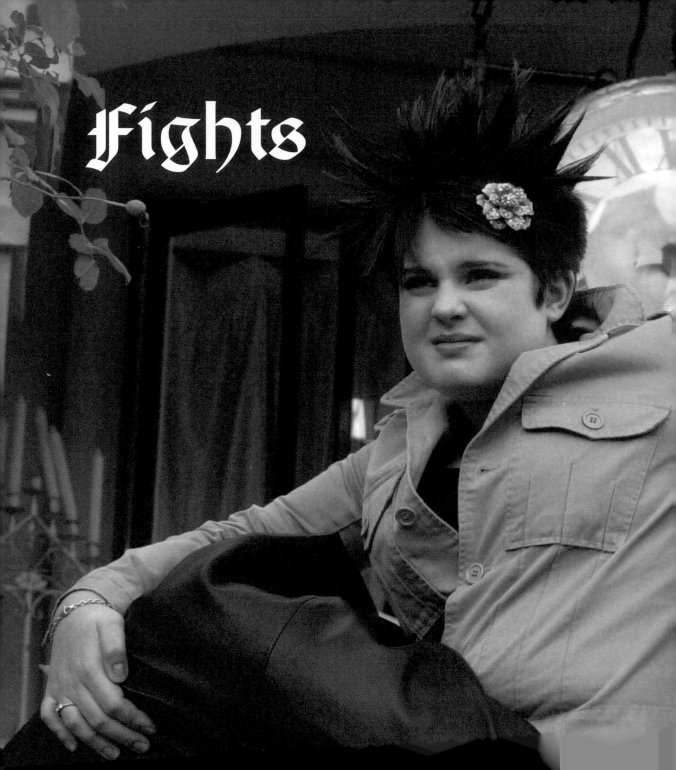

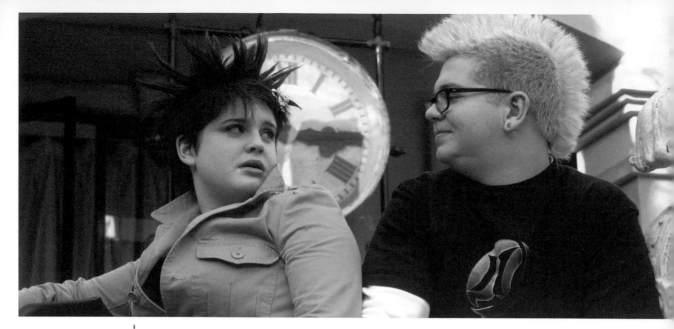

FIGHTS | † Chapter VII

The fights are furious, frequent, and then forgotten. "Kelly and I average about two or three a week," Jack says. "Then it's over. We don't think about it again." "Yeah, we get over them quickly," Kelly adds. Even Sharon, who still laughs when she thinks about Ozzy getting mad at her for wanting bubbles in his concert ("Sharon, I can't have bubbles. I'm the Prince of #$&*ing Darkness"), says the arguments are "perfectly normal." You be the judge of that. Here are their top 10 fights:

 VS.

Fight #10

(HE'S JUST SICK OF HER)

KELLY: "He's been running around talking crazy #$&* about me, and I found out. And I think it's more that he feels guilty about doing it to try to be mean, and so he gets in a bad mood."

JACK: Kelly is a bitch.

OZZY: What?

JACK: I've had enough of Kelly, Dad.

OZZY: What's going on now?

KELLY: Jack can do anything he wants to, say anything he wants, talk all this #$&*, but if it comes back to him, he just freaks.

JACK: Dad, I . . .

OZZY: Why don't you ask your own . . .

JACK: Dad, I have. She won't do #$&* at all. She goes, "Oh, I will, I will," but she hasn't and she won't. Dad, I'm really . . . I'm about to lose it with her. She ditched Sarah, who's supposed to be her best friend, and just left us. If it wasn't for me, she'd still be at the #$&*ing mall with her dumb friends. See, it was me who said, "Hey, Kelly,"

when she used to hang out at the mall with her little stupid friends. I was like, "Kelly, come with me to some clubs, we'll hang out . . ."

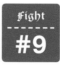 **VS.**

Fight #9

(OVER HER FEELING A LACK OF ATTENTION)

KELLY: Jack, stop telling people you're Ozzy Osbourne's son to get into places, because you're a #$&*ing loser.

JACK: Kelly was a big-ass mall rat, and I just started taking her to clubs and then she kind of just, you know, told me to #$&* off and that was it.

KELLY: What really bothers me is, like, when I, like, open a magazine and read something on my brother and it never says . . . never says anything about me. It's always like, "Jack's working at Epic," right? And it makes me feel like I do nothing and I'm such, like, the loser kid, like, and I have nothing to show for my achievements or anything that I do, right? And in actual fact, I found the band that Jack got the development deal—me and my friends did—and all this stupid #$&*. And it's just, like, do I get any credit for it? No. I would just really appreciate some credit."

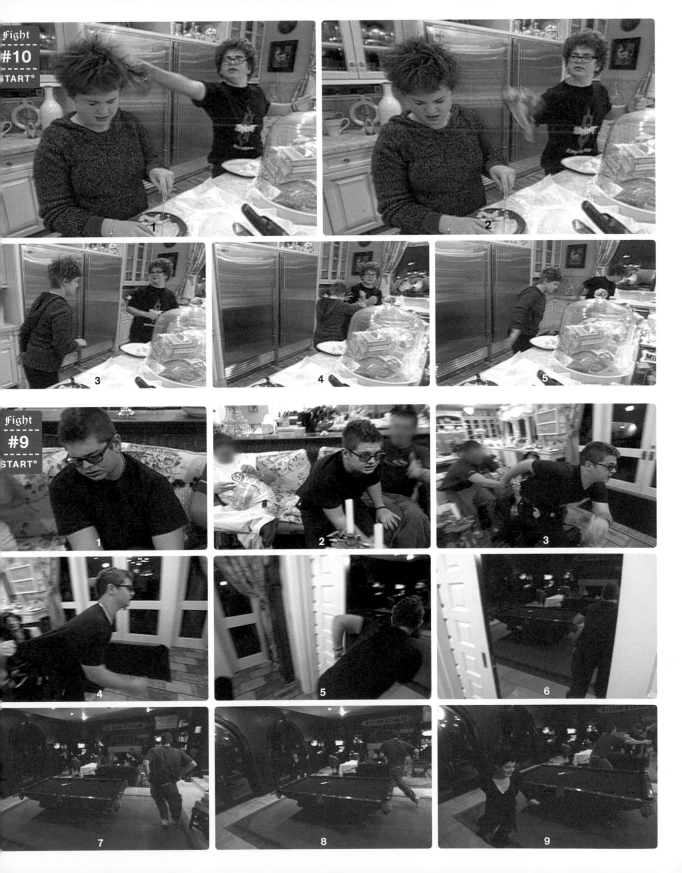

#8

Fight #8 vs.

(BECAUSE HE DOESN'T WANT TO GO TO SCHOOL)

JACK: When you say "nanny" to Melinda, she actually thinks, wipe my ass, put me to bed, tuck me in, bring my cocoa in the morning when I wake up. I'm sixteen in six days. Come on, really.

MELINDA: Please, come on. Come on, Jack, please. We have to to go.

JACK: Give me two minutes. I guess, you know, I don't need a nanny. But Mom still insists. She's kind of pissing me off.

MELINDA: Forty minutes late for school already. I'll just call them and let them know that you're running late. Come on.

JACK: All right.

MELINDA: Good on you.

JACK: Don't use that Australian Pig Patin on me. I have to brush my teeth.

MELINDA: Go.

JACK: Shut up. You're fired.

MELINDA: You can get my Christmas present from in there if you want.

JACK: I'm going to get you a broken alarm clock so you get up in the morning.

MELINDA: #$&* you. See you at three-fifteen.

Fight #7 vs.

(OVER LOLA)

OZZY: You haven't got that dog around here?

JACK: No.

OZZY: Jack, you know, I got to talk to you about that. Listen, Jack. This house has cost me a #$&* and she demolishes my bed. She chews my furniture. It's not on, babe. I— I love Lola, don't get me wrong. I really love Lola, and Jack loves Lola, but Jack also loves to go to the night #$&* clubs, and what I don't like doing is pick—I don't mind a #$&* Pomeranian turd, but when they're #$&* bull-dog loads, you got to get an earthmover and a #$&*ing gas mask to go in the kitchen. It's like #$&* plutonium turds.

KELLY: Did somebody give Lola away?

JACK: Yeah.

KELLY: Can I just say one thing, Jack, before you call Mom? You don't give a #$&* about the dog.

JACK: Kelly, you don't give a #$&* about your dog, your cat, your #$&*. Close your mouth.

KELLY: Yeah, I do.

JACK: You don't, Kelly. Mom? You know I'd really, really, appreciate it if you'd start telling me when you gave my dog away. You

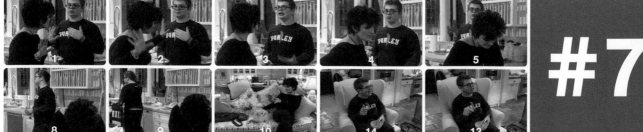

#7

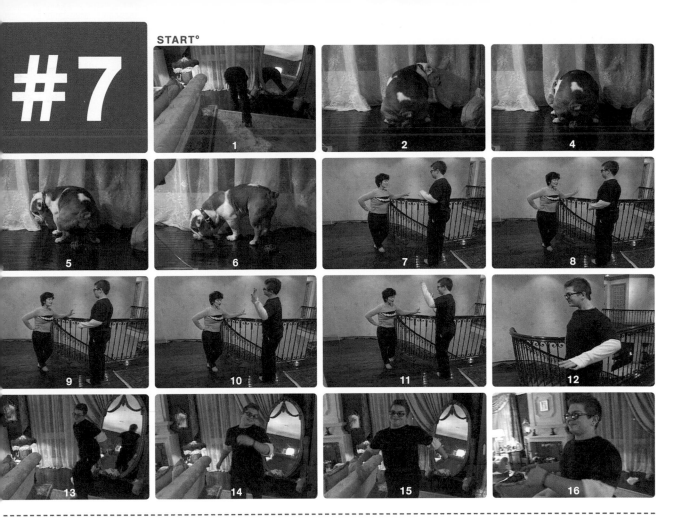

OZZY:
YOU GOT TO GET AN EARTHMOVER AND A ████ING GAS MASK TO GO IN THE KITCHEN. IT'S LIKE ████ING PLUTONIUM TURDS.

know this is really getting outrageous. Two times now you've done this, Mom, and I've really had enough of it. How would you like it if I would give Minnie away without telling? 'Cause I know a lot of people might like those dogs. It's not on. I don't give a #$&*. I want my dog back.

KELLY: Don't talk to her like that!

JACK: She gave my dog away.

(CHRISTMAS DINNER AT THE OSBOURNES')

JESSICA: Ozzy, I have a question.

OZZY: Go on.

JESSICA: I don't like the . . . well, it's kind of a comment. I don't like the redness. I think we should go back to black.

KELLY: #$&* off, Jessica.

OZZY: The red what?

KELLY: That's so rude.

SHARON: What redness?

JESSICA: The hair.

SHARON: In the hair?

JESSICA: Yeah.

SHARON: Why?

KELLY: Jessica, Jessica, how about you do me a favor?

OZZY: Jessica, you know, can I say something?

JESSICA: Yeah.

OZZY: Mind your #$&* own business.

JESSICA: But I'm being honest.

KELLY: Jessica, it's so rude!

JESSICA: Ow! You, first of all, are hurting me.

KELLY: And you, second of all . . .

JESSICA: Okay, I'm sorry.

KELLY: It's rude. It's rude. Don't talk like that.

JESSICA: I'm sorry.

SHARON: Christmas fight. The Christmas fight. It's finally here.

OZZY: I'm going to bed. #$&* the lot of you.

KELLY: I think it's really rude. You don't go to someone's father, "I don't like the redness in your hair." It's #$&* rude. I would never go to her father, "Oh, I don't like your baldness. Maybe you should get a toupee." I mean, come on, I would never.

(AFTER SHE TELLS HIS PARENTS THAT HE SMOKED POT)

MELINDA (TALKING TO OZZY ON THE PHONE): Jack got home at twenty past four. So I was vomiting with fear. The thing is, is that I was worried sick, Ozzy, that he was #$&*ing dead in the middle of Sunset Boulevard.

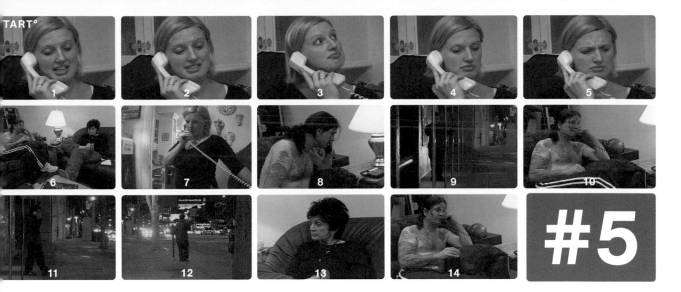

OZZY: What?

MELINDA: Usually we get along very well and he's very good and respectful, but it's just that he's got caught doing something wrong, and he's pissed off at me because I told Sharon.

OZZY: If he smokes a bong, you must tell me, because he's going to have that #$&*ing thing shoved up his butt. Since we're not in town, it's your discretion.

MELINDA: Okay, Ozzy.

JACK: #$&* you, Melinda. #$&* you!

MELINDA: No, Jack.

JACK: No, Melinda. #$&* you.

TART°

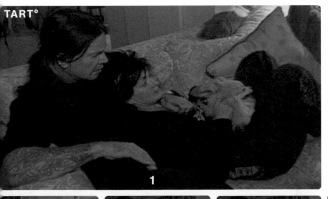

(OVER CONCERT DETAILS)

OZZY: I am not going to do it, Sharon.

SHARON: If he says "Sharon" one more time. I've changed my name. Don't call me Sharon.

OZZY: I don't want this #$&*ing stupid Santa Claus machine landing on the #$&*ing stage. I just want to play rock and roll, man.

SHARON: A show tomorrow and then a show in Albuquerque.

OZZY: You can't do that, Sharon. See, you'll blow me out. I'm going to break my voice. You know that. I can't do that anymore. I'm fifty-two years of age. You should have known that before you booked this #$&*ing thing. I'm pissed off now. How long have we been working together? #$&*ing twenty-two years. You, all you think about is the #$&*ing money. No, Sharon, its wrong. It's abuse, doll. I won't do it.

#3

START°

KELLY (TO OZZY): It's your #$&*ing daughter. I just got a call when I'm in Tiffany from some woman telling me how I should prepare my vagina for my gynecologist appointment tomorrow. She booked me a #$&*ing gynecologist appointment. She's out of her #$&*ing mind. I don't think it's any of her business. I'm like, "Aimee, my teeth, my car, my vagina, are *my* business. Like, now they stick a finger up your ass, and no one is sticking a finger up my ass.

OZZY (TO KELLY): You haven't been doing something wrong, have you? You haven't been getting you-know-what? I'm thinking now, She's been up to no good. She might be pregnant and all this. You haven't been playing doctors and nurses, have you?

KELLY: I'm going to book her a #$&*ing breath test because her breath smells like #$&* all the time.

OZZY (TO KELLY): "YOU HAVEN'T BEEN PLAYING DOCTORS AND NURSES, HAVE YOU?"

120

 Fight #2 **VS.**

(ABOUT HIS FASCINATION WITH WEAPONS)

KELLY: A fifteen-year-old boy should not be walking around with #$&*ing knives and rifles.

JACK: Have you ever been a fifteen-year-old boy? No.

KELLY: Shut up.

JACK: I was the one behind the [paint pellet] gun, all right?

KELLY: Yes, I was the one that #$&*ing got shot, all right?

JACK: Now, why do you still hold this grudge from . . .

KELLY: Because you shot me.

JACK: From six years ago? And you still get angry when we talk about it, Kelly.

KELLY: Because you #$&*ing shot me!

JACK: What's your point?

KELLY: You're an idiot.

JACK: It was a pellet, Kelly. It was about…half the size of my fingernail.

KELLY: Regardless.

JACK: It would be no different than a rock getting thrown at you, Kelly. Just a very fast rock.

KELLY: It went through my #$&*ing leg.

JACK: You've done some #$&* to me.

KELLY: I haven't shot you.

JACK: You laughed when I got smacked in the face with a baseball bat.

KELLY: Because it was funny.

121

START°

Fight #1

vs.

SHARON: I'm going to bollock the neighbors for making noise. Let's go and say, "How dare you play that dreadful music?"

JACK: Can we bring the gun? You wankers have no respect for your neighbors.

SHARON: You said you wanted to beat up Ozzy Osbourne. The front door is open. Come on. Playing your awful, middle-aged music for everyone to hear. Come on, big boy, come here, come on, cocky little Englishman. Living off Daddy and Mommy's money, do you? I hate that small-mindedness. I hate it. When he comes here tomorrow, I want to hold him down and piss on his head.

JACK: We should get Pat Boone back. We should see if he wants to move in next door.

SHARON: Was he the best neighbor ever? He was such a lovely man. I've never known people so noisy in my life. I thought we were bad, Jack.

JACK: I know.

OZZY: I'm not a party pooper by any means, but they don't own this #$&*ing street, you know? I try and be a nice, neighborly #$&*ing person. If they're going to #$&* with me, they're #$&*ing with the wrong person because I'll start #$&*ing throwing dead animals over their #$&*ing thing. I don't give a #$&*. I'll throw #$&*ing pigs guts and things over there. If they party tonight, war's on. I tell you, we've got to get some reprisals here. If they want a war, we've got to give them one. I'll get a pig's head from the butchers. That will #$&* them up.

JACK: I'm trying to get to bed, and you guys are singing "The Whole World's in My Hand." I'd rather you shut the #$&* up.

KELLY (TO SHARON): They said you were a crazy whore.

SHARON: Well, they're right with that one.

SHARON (TO POLICE): I threw a bagel and a piece of ham.

SHARON: It will probably end up really ugly, going through the lawyers, but one thing's for sure, I'm not moving. I am definitely not moving. Ozzy, knock wood; you could be done for manslaughter.

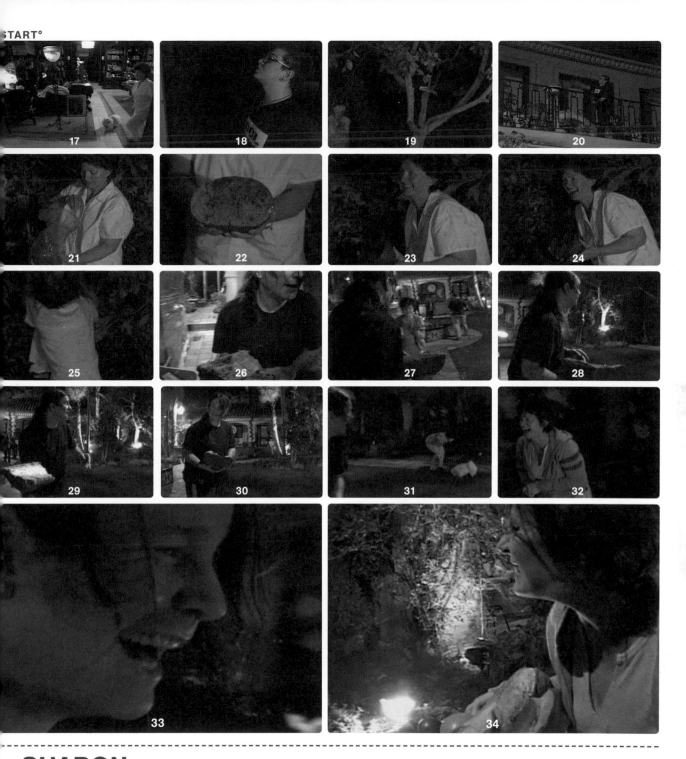

SHARON:

"WHEN HE COMES HERE TOMORROW, I WANT TO HOLD HIM DOWN AND PISS ON HIS HEAD."

Episode Guide #8:
No Vagrancy

Patience and hospitality—the Osbournes, normally overly generous and forgiving, run out of both, thanks to burnout skateboarder Jason Dill and disobedient bulldog Lola. It appears as if the inmates have taken over the asylum, and Ozzy and Sharon want it back.

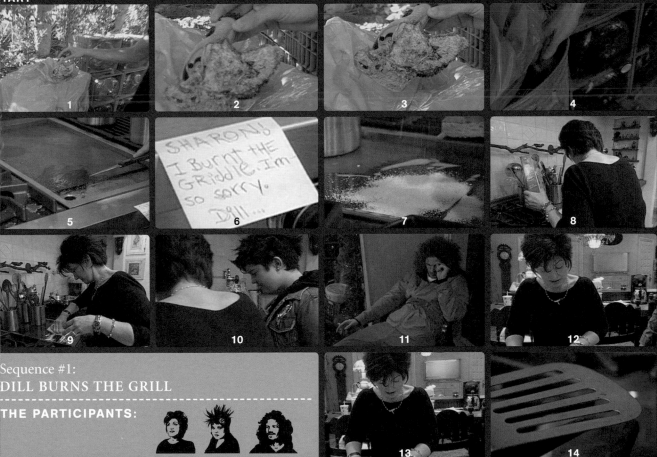

1 **2** **3** **4**

5

SHARON! I Burnt THE GRIDDLE. Im so sorry. Dill...

6 **7** **8**

9 **10** **11** **12**

Sequence #1:
DILL BURNS THE GRILL

THE PARTICIPANTS:

13 **14**

Sequence #2:
JACK GETS THE CALL

THE PARTICIPANTS:

At Jack's invitation, disheveled Jason Dill crashes on the Osbournes' couch and stays, apparently, indefinitely. Is this guy for real? Yes. Is he some kind of stunt set up by the show's producers? No. Following in the tradition of Kato Kaelin, he is the houseguest from hell, and Dill's omnipresence creates a pickle for Ozzy. "Is this a permanent #$&*ing solution-uh, situation?" he asks. "If so, I want #$&*ing rent."

Lola is equally annoying. It's not that Ozzy doesn't love Lola, as he explains, but he can no longer allow the dog to terrorize his house with plutonium like poops. Jack doesn't pay attention to his dad's complaints until he's out to dinner with Kelly and Dill and gets a call from Sharon. She has given Lola away. *(Sequence #2)*

1 **2** **3** **4** **5**

Sequence #3:
WHISKEY PEE

THE PARTICIPANTS:

JASON:
"OZZY NEVER REMEMBERS ME. EVERYTIME I MEET HIM, HE SAYS 'NICE TO MEET YOU.'"

Jack and Kelly are busted for coming in at one A.M. and waking up Ozzy and Sharon. According to Kelly, her parents wanted them to bring friends to their new house, but as she says, "When we move in, it's like, 'No friends, be quiet!' " It's a rough life, but Jack takes refuge in the fact that they put up with Dill, who says, "Your mom respects my opinion, though." Clearly, the guy has landed on his head one too many times.

Finally, Dill has to go. After burning the griddle in the kitchen (*Sequence #1*), he leaves a note apologizing to Sharon, who gets ticked off even more upon finding a bottle of Jack Daniels in Jack's bedroom. She tries pissing in the bottle, but Kelly insists that she stop. "Oh, all right, Kelly, Miss Drama Queen," Sharon says. There's a private confab between Sharon and Jack. Next, Lola is returned for a visit, but Dill gets the boot. "We need some quiet family time," Jack explains.

BEST LINES

† **Ozzy:** "I really love Lola, and Jack loves Lola . . . what I don't like doing is pick—I don't mind a #$&*ing Pomeranian turd, but when they're #$&*ing bulldog loads, you got to get an earth-mover and a #$&*ing gas mask to go in the kitchen. It's like #$&*ing plutonium turds."

† **Ozzy:** Who the #$&* is Jason?

† **Jason:** Ozzy never remembers me. Every time I meet him, he says "Nice to meet you.'"

HIGHLIGHTS

† Another Ozzy battle with technology, as he tries to watch a DVD on his computer and fails: "You need to be a #$&*ing rocket scientist."

† After finding a bottle of liquor in Jack's room, Sharon threatens to pee in the bottle!

† Lola yawning a gigantic yawn

† Lola barfing

START°

1 2 3

4

5 6 7

Sequence #4:
MAN VS. MACHINE

THE PARTICIPANTS:

BAD WORD BOX SCORE

26 8

6 12

On the Road

ON THE ROAD WITH THE OSBOURNES † Chapter VIII

After the October 2001 release of his album, *Down to Earth*, Ozzy hit the road. Some rock stars hate this part of the gig. Others love it. And Ozzy? "I'm one of those people who can't stand being on the road, and when I get off it, I want to be back out there," he says. "I'm home for a day, look around, find all my bits and pieces, play pool in the pool room, and then say, 'Sharon, I'm bored. Get me a tour.' I've got permanent ants in my #$&*ing pants. I can't lie down in the bed without getting up and looking in the bathroom." As for the rest of the family, Sharon says, "We love being home, but all of us like a bit of an adventure."

IN A LIMO ON THE WAY TO LENO, SHOW #3
OZZY: I don't like traveling #$&*, you know?
SHARON: Look at the ceiling. It's like Kelly's bedroom.
OZZY: Oh, wonderful, we'll live here.

GOING TO AN IN-STORE APPEARANCE TO PROMOTE HIS NEW ALBUM
KELLY: I don't know how all these people know my name, and I'm just like . . . it's. . . . I get really shy. I hate people touching me. I can't stand it.
OZZY: Oh, they'll let me out and I'm going to get killed.
SHARON: Go for it, my darling.

AT HOWARD STERN, SHOW #3
OZZY: "We're going to talk about sexual intercourse and things. That's why I brought the wife, because I forgot what it's like."

TALKING TO CONAN O'BRIEN ABOUT OZZY DOLL, SHOW #3
OZZY: Rock and roll!
CONAN: How do you actually get through a metal detector? Look at this. That's impressive. How many crosses do you have there?
OZZY: Well, I need them—need every one.
CONAN: Look at that.
OZZY: And it urinates at the Alamo when you go there.
CONAN: Wait, yours urinates?
OZZY: Yeah.
CONAN: Mine urinates, but it's not supposed to. We don't know what the problem is. We can't get it to stop.

OZZY:
"WE'RE GOING TO TALK ABOUT SEXUAL INTER-COURSE AND THINGS. THAT'S WHY I BROUGHT THE WIFE, BECAUSE I FORGOT WHAT IT'S LIKE."

AT *TOTAL REQUEST LIVE* WITH P. DIDDY, SHOW #3
OZZY: I'm so glad you got off that . . . that court case went okay.
P. DIDDY: Yeah, thanks a lot, man. I'm so glad about everything that's going on for you. Big fan of Ozzy Osbourne, no bull#$&*.

OZZY AND SHARON FROM SHOW #3
SHARON: I think you're still asleep.
OZZY: I don't know what planet I'm on. I feel like I'm . . . I was fired out of a cannon on Monday, and I ain't landed yet.

OZZY, SHARON, AND KELLY IN THEIR HOTEL ROOM, TALKING TO JACK ON THE PHONE, SHOW #3
SHARON: Jackie will be home soon. He's not had a good time.
OZZY: What?
SHARON: Jack was on a camping trip at school.
OZZY: What?
KELLY: I wouldn't want to go #$&* camping.
SHARON: He didn't like it there.
OZZY: I told him to buy the proper #$%ing backpack, instead of that stupid thing that he got from . . .
SHARON: No, he just didn't like it there. It was too hippy-ish.
KELLY: No, yeah, they make you, like, feed a tree before you feed yourself.
OZZY: How the #$&* do you feed a tree? What, do you put a ham sandwich by the tree?
KELLY: Yeah, you put a sandwich by the tree. It's like the tree of the gods.
SHARON: And they sing by the campfire at night.
OZZY: Oh #$&*.
KELLY: See, Mom, I can't do that and take it seriously. When I was in . . .
SHARON: "Kum Ba Ya" . . . what's that?
OZZY: "Kum Ba Ya" . . .
SHARON: Oh my God, last night we stopped at . . . what was it? Roy Rogers?
KELLY: Roy Rogers, like, takeout.
SHARON: Who's the difference between Roy Rogers and Will Rogers?
KELLY: That was what I was wondering. Who the #$&* is Will Rogers?
OZZY: I don't know.

START°

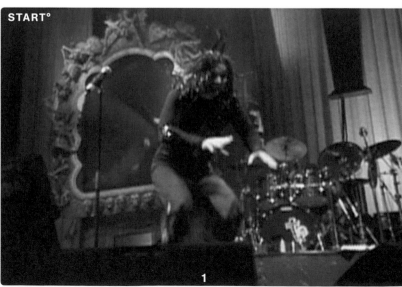

KELLY ON THE PHONE TO OZZY WHILE HE IS ON TOUR, SHOW #7

KELLY: Hi, Daddy

OZZY: Hi, darling.

KELLY: How are you doing?

OZZY: All right. I just got here. It's colder than a witch's tit. It's snowing. It's absolutely . . . it's like beyond cold.

OZZY ONSTAGE, SHOW #7

OZZY: "Rule number one: The crazier you go, the crazier Ozzy Osbourne goes!"

SHARON, JACK, AND KELLY, WAITING IN A CHICAGO HOTEL ROOM BEFORE SURPRISING OZZY ON HIS BIRTHDAY, SHOW #7.

SHARON: Where's the chocolate?

KELLY: Oh, lots of chocolate.

SHARON: I was having withdrawal while I was on the plane.

KELLY: We're here in Chicago 'cause it's our dad's birthday on Monday, and he basically told us to #$&* off . . . but we're surprising him. And if he finds out we're here before his birthday, he's going to go mental.

SHARON: And he's pissed off with me. He's not talking to me. So if he sees me before his birthday and before there's kind of, like, an audience around to save me, he'll be pissed off that we're here.

KELLY: Yeah.

JACK: Why? Why is he pissed at you, though? 'Cause of the house?

SHARON: Yeah.

JACK: Why? Because he says you spend too much money on it?

SHARON: Yeah. So we're just going to have a nice low-key dinner.

SHARON, KELLY, AND JACK IN THEIR HOTEL ROOM, SHOW #7

SHARON: Wouldn't it be terrible if we get here and we've come all this way, and he doesn't want to see us?

KELLY: Well, I don't get why we came anyway, if we're not sure if we're wanted or not.

SHARON: Because we love him.

JACK: Because it's love, Kelly.

KELLY: He's a bastard if he doesn't want us here.

SHARON: Kelly, stop that crock.

OZZY BEING INTERVIEWED AT THE RADIO STATION, SHOW #7

DJ: What would you do if it stormed and you had to stay in Grand Forks for another three days?

OZZY: Everybody goes on about the cold. "Is it going to get colder, man?" It's not the end of the world, you know? I'd rather be here than in Afghanistan right now.

WAITING FOR OZZY TO SHOW IN THE RESTAURANT, SHOW #7

KELLY: I know he's going to be, "What the #$&* are you doing here?"

JACK: Here he comes.

SHARON: Hi.

OZZY: How did you get here?

SHARON: We've been hiding from you all day.

OZZY: Have you really? Where's the babies? Where were you coming from today?

SHARON: The room.

OZZY: In the hotel?

JACK: We're like two floors below you.

OZZY: You bastards.

SHARON:
"SO THE AMBULANCE CAME, AND HE'S TOTALLY ████████ING NAKED IN THE MIDDLE OF WINTER, IN CONNECTICUT."

START°

Sequence #3:
CALL SECURITY

THE PARTICIPANTS:

TROUBLE ON THE ROAD, SHOW #9

SHARON: One of our eleven truck drivers got into an accident yesterday. We found out today.

OZZY: He was stoned.

SHARON: No.

OZZY: Drunk?

SHARON: Getting a #$&* from a hooker while he's driving.

OZZY: Oh, that'll do it.

SHARON: And he was naked.

JACK: Yeah.

OZZY: Oh, that'll #$&*ing do it, great.

SHARON: So the ambulance came, and he's totally #$&*ing naked in the middle of winter, in Connecticut.

SHARON IS ON THE TOUR BUS, FINDING OUT THAT MICHAEL, THE SECURITY GUARD, HAS BEEN ARRESTED, SHOW #9 (SEQUENCE #3)

OZZY: Hey, find out if my watch is gone.

SHARON: What watch?

OZZY: My Van, no, my Van Cleef.

SHARON: Where did you leave it?

OZZY: By the side of the bed.

SHARON: Oh, for #$&* sake.

OZZY: It's gone. Oh, my jewelry, Sharon, get that mother#$&*. My jewelry, my . . .

SHARON: I'm getting on the phone right now.

OZZY: Get on the phone, check my watch, my jewelry. If he's

OZZY:
"GET ON THE PHONE, CHECK MY WATCH, MY JEWELRY. IF HE'S IN THERE, I'M GOING HOME AND I'M GOING TO WHACK THAT ████ER. AND OH, I'VE GOT MY GOLDEN BELT WITH ME, HAVEN'T I? CHECK EVERYTHING. CHECK EVERYTHING."

in there, I'm going home and I'm going to whack that #$&*. And oh, I've got my golden belt with me, haven't I? Check everything. Check everything.

SHARON: See, I honestly . . . maybe I'm naïve and it might sound crazy, but I think he really liked us. And I don't think he wanted to steal off us. You're not going to believe what I'm going to tell you.

OZZY: No. He had a gold belt on when he got nicked.

SHARON: No, but when he was arrested, he had one of your T-shirts on.

SHARON AND OZZY IN THE NYC HOTEL ROOM, WHEN THE BELLMEN ARE BRINGING UP SHARON'S PURCHASES, SHOW #9 (SEQUENCE #4)

SHARON: Yeah, I do. I like Christmas, I do. I love buying presents. And it's another reason for me to shop, so I love that.

OZZY: What the #$&* is this, Sharon? What are these for? Sharon, I'm asking you a question, darling.

SHARON: Okay, all right, darling. One of these is . . .

OZZY: A black bag.

SHARON: A black bag for Smitty.

OZZY: Smitty? Yes. And does he have a twin brother?

SHARON: He's got a twin brother.

OZZY: You've got triplets.

SHARON: And they've had triplets. And I have no #$&*ing idea what's in the other one.

OZZY: This looks very dangerous to me. It looks like I'm going on tour for the next nine years.

SHARON: Look, I can't #$&* it, and I can't wear it, so I don't want it.

OZZY: But what is it, Sharon? You must know what it is. It's got that Gucci vibe there. When I was a kid, I'd get one gift. I'd get a smelly old sock. Mix a few nuts in, a couple of pennies, an apple and an orange, and that was it.

ANOTHER SCENE IN THE HOTEL ROOM, PACKING, SHOW #9

SHARON: Your dad's pissed off. What's up with him?

JACK: He wants to know how we're going to get all those bags on the plane.

SHARON: Well . . .

JACK: We're never going to fit anything.

SHARON: Yeah, we are.

JACK: Okay, we going to tie it to the wing with duct tape? You gotta think about these things.

SHARON: I love Christmas. I love the whole buildup. We can all eat together, give each other gifts, and then the kids can go out and do what they want to do. Ozzy and I can stay in with the dogs and the cats and just have a nice quiet evening.

OZZY: Well, you can keep on #$&*ing wishing—Ozzy ain't gonna be there.

Sequence #4:
GUCCI
BAG LADY

THE
PARTICIPANTS:

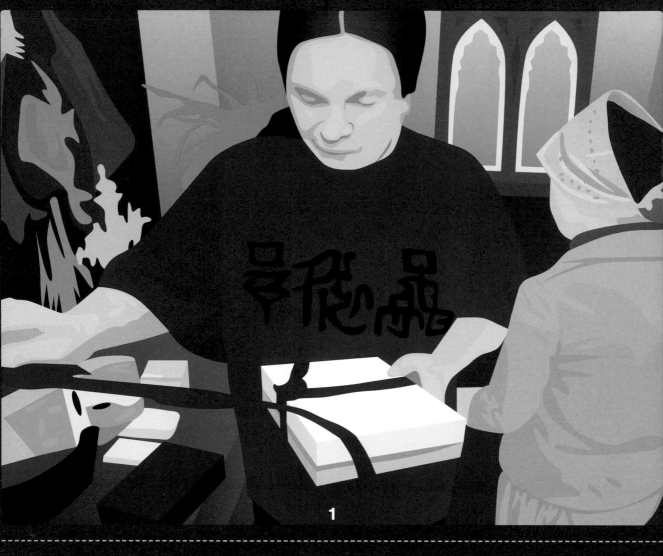

1

Episode Guide #9:
A Very Ozzy Christmas

It's #$&*ing Christmas, and two employees have been more naughty than nice. While vacationing, er, shopping, in New York, Sharon learns one of their truck drivers was in an accident. Police found him naked in his truck with a prostitute. Sharon is not as amused when she hears that Michael, the security guard, was arrested back home for allegedly burglarizing the house behind them. Later, the charges are dropped—Michael is innocent—but Ozzy still threatens to "whack that #$&*er" if he finds Michael in his house. Hey, at least Michael got an Ozzy T-shirt out of his gig at the house; he had one on when he was arrested.

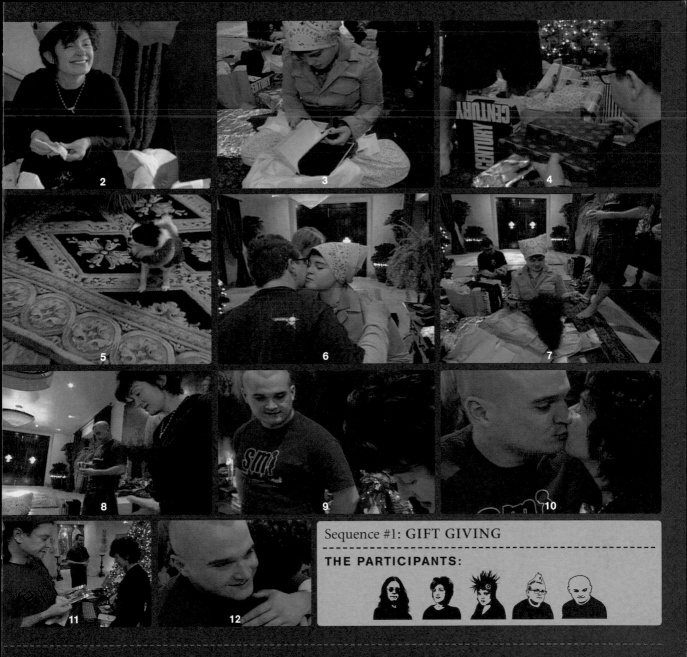

Sequence #1: GIFT GIVING
--
THE PARTICIPANTS:

Among the Osbournes, Sharon is the only one who admits to loving Christmas. Why? It gives her an excuse to shop—no, to power shop. As Ozzy watches bags from Gucci and other posh stores stream in to their hotel room, he flips out. By comparison, he recalls his own impoverished childhood, when all he'd get for Christmas was a "smelly old sock" with a few nuts, a couple of pennies, an apple, and an orange.

Christmas morning finds the Osbournes back home, behaving like any other family, as opening presents by the tree leads to insults, abuse, and then outright anger. They are joined by Louis, Ozzy's son from his first marriage. Following Christmas rituals, the family prepares to feast, and Ozzy boasts of his gravy. "We're going to hear about this #$&*ing gravy for the next year!" moans Sharon, who looks incredibly pleased when, after Kelly's friend insults Ozzy's hair, she is able to say, "The Christmas fight is finally on." Ozzy seems equally delighted by the holiday spirit. "We're the Osbournes," he says. " I love it!"

Sequence #2:
PANTRY RAID

THE PARTICIPANTS:

SHARON: "I THINK TELLING JACK TO OFF IS BET- TER THAN SAYING GET THAT D**K OUT OF YOUR ASS." KELLY: "I SAID *STICK*."

BAD WORD BOX SCORE

25 **21**

10 **10** **3**

BEST LINES

† **Sharon:** One of our eleven truck drivers got into an accident yesterday . . . getting a #$&* from a hooker while he's driving.
Ozzy: Oh, that'll do it.

† **Sharon** (re: a gift): Look, I can't #$&* it, and I can't #$&*in' wear it, so I don't want it.

† **Ozzy:** "When I was a kid, I'd get a smelly old sock. Mix a few nuts in, a couple of pennies, an apple and an orange, and that was it.

† **Sharon** (venting to Ozzy about Jack):
He's got an army haircut. He's got cocaine [written] on his chest and a #$&*ing knife in his pocket. Police will look at him and arrest him.

† **Sharon:** I think telling Jack to #$&* off is better than saying get that d**k out of your ass.
Kelly: I said *stick*.

HIGHLIGHTS

† Ozzy dancing to tunes from a James Brown singing toy in the hotel

† Ozzy and Sharon share a moment of affection: "I love you," he says. "Now #$&* off."

† Hearing Michael's been arrested, Ozzy freaks out that his belt and watch might have also been stolen

† Ozzy getting locked in the pantry

† The Osbournes feasting at the Christmas dinner table, arguing like every family does during the holidays

What We Didn't

† **JT:** Marilyn Manson was supposed to come over for dinner one night. There was a whole dinner party planned, but he canceled at the last minute. That would've been pretty fun.

† **MELINDA:** The fight with the neighbors wasn't an ongoing thing. I remember Sharon being away when they first came over. I was the only one home. The housekeepers brought them in, and they said, "Oh, hello. We're from next door, and we just wanted to drop by and see Mrs. Osbourne and introduce ourselves properly." As they said that, they were fully checking out the crosses on the wall and whispering, "Dear me." At that stage, Sharon had already had a go at them about their music. They had this little card they gave me. As soon as they left, I called Sharon. I phoned Sharon, and she said, "Open the card." It said, "Dear Mrs. Osbourne, sorry we got off on the wrong foot. Love to have a chance to have a cup of tea with you." Sharon said, "You know what? I appreciate that kind of thing. If they have the courage to come and apologize and want to fix things, fine, I don't care. Whatever. I'll go have a tea with them when I get back." But the tea never happened, and then they got out of hand with the music. People don't realize, Kelly's bedroom is on the same side of the house as the neighbors', and so she has it the worst. Seriously, when they have the music on, it's like a disco in her room.

† **LISA VEGA (THE OSBOURNES' PUBLICIST):** People on the crew were constantly stepping in poop and dragging it through the house.

† **KELLY:** There's no story behind my tattoo. I just wanted one and went out and got it. I don't see what the big deal was. I hadn't been thinking about it for a while. Five minutes before I got it, I was like, "Oh, I want a tattoo," and so I did it. It didn't hurt any more than I expected. I put it down where no one would ever see it, right on my underwear line, so unless I physically pull my pants down, you can't see it. As far as my parents' reaction, my thing is, if you're man enough to do it, you're man enough to admit it and face the consequences.

† **SHARON:** We did an awful lot of Christmas shopping in New York. We saw the bags, all those glorious bags. But what we didn't see is that my credit card maxed out, so I was stealing Ozzy's credit card and taking it to the stores. I don't think people needed to see me stealing.

† **LISA VEGA:** Ozzy's promo tour was five cities in five days. It was crazy. At the time his record came out, it was neck and neck in terms of sales with Enya's. We wanted to challenge her sales. So we nicknamed the tour "Operation Enya." Ozzy averaged about two thousand fans each stop, and he took photos with anyone who wanted one. But here's the weird part: A lot of parents who came out brought their kids and dressed them up as bats. It was so funny. Ozzy did not bite a single one.

† **KELLY:** I didn't want to have to have a birthday party. I hate having them. That was a fully contrived MTV thing. I would have rather just gone out with my friends and done one little thing instead of being #$&*ed out. Only when I was really young do I have good memories of birthday parties. I mean, you love that #$&* when you are a kid. I don't give a #$&* about that kind of stuff anymore. I don't like parties.

† **JT:** We knew Jason Dill was going to develop into a great story. Ozzy's so nice and Sharon's so polite, they won't tell you when they're upset. But we'd ask Ozzy questions like, "So, who's Jason?" and he'd say, "I don't know. Who the #$&* is he? Let's charge him rent."

† **MELINDA:** Well, I caught Jack smoking pot and of course—it was a couple of things. It was the pot and then he came home on Halloween night at four A.M. and I was so worried. I was "Oh my God," and then you start thinking, Well, who's he gone out with? I don't really know. In fact, I don't even have any numbers. What if Sharon asks who he went with, I can't tell her. All these things go through my head. Something terrible happened, or he was stuck somewhere. Then when he came [home] and he's been out with friends, I was really cross with him for what he'd put me through. I said, "From now on, every kid who walks through I'm getting their phone number." The pot thing was—you know what, I'm only twenty-four—teenagers do that. But maybe he does it again in two months' time and something happens to him and Sharon will say, "Why didn't you tell me?" I said, "Sharon, this is what happened." She said, "You're joking." Then Jack got upset. But Ozzy and Sharon were like, "Jack, you know Melinda isn't going anywhere. You've just got to #$&*ing live with this and get over it." When I fight with Kelly and Jack, it's like fighting with your brother and sister. We spend some time apart, and then it's like nothing ever really happened.

† **KELLY:** I don't like being tricked. I'll cooperate if I like the idea and all, but if you're going to sit there and lie to me, then it just pisses me off. Like when we had the family meeting. I hate that show. I think it is so stupid and so #$&*ing cheesy. I didn't want to go in there and do it. I knew they had hidden cameras in there by the way my mom was acting. It was so ridiculous. I don't like stuff like that.

† **LISA VEGA:** When Fox News's Greta Van Susteren came to the house to interview Sharon and Ozzy, she had an elaborate lighting system, which was set up in Sharon's sitting room. The lighting guy didn't anchor one of the lights properly and it fell—no, it crashed—in the middle of the interview and broke an antique table worth thousands of dollars. Sharon's and Ozzy's expressions were worth millions.

† **MELINDA:** When Jack went on his school camping trip, he took his cell phone, even though he wasn't supposed to. And he called me a couple times and said, "Melinda, I hate this place. I'm miserable." I said, "Jack, if it's really bad, I guess I'll have to come and pick you up." He said everyone was hating it and "we're feeding trees. They're hippies, Melinda. They're hippies." I think he had fun being crazy and getting into trouble. When I picked him up, he was very ready to come home.

† **JACK:** You know what? Looking back on the camping trip, I really did have fun. So I guess I take back what I said about it.

† **GREG JOHNSTON:** The crew turned the downstairs guest rooms into a production office, and from the start we didn't want to show the crew. However, Ozzy came down every morning, made coffee, and then walked into our offices. We were the people living under the stairs. He ordered us coffee. The funny thing was, in the early days after they moved in, je didn't know his phone number or the address. So at night when he ordered food, he'd come in and ask us what the address and phone number was.

† **GREG JOHNSTON:** When we got back to the house after Ozzy did the *Tonight Show*, Michael the security guard—who was supposed to be out on the perimeter—was in the kitchen, watching a football game on TV and eating. I was like, "What's he doing in the kitchen?" I wondered if he knew the Osbournes were going to be home in ten minutes—or if he cared. At this point, Sharon knew him but Ozzy had never met him. So Ozzy comes in, adn here's this stranger in his kitchen. But Ozzy just sits down as if it was the norm, doesn't say anything to Michael, and proceeds to watch himself on the *Tonight Show* with Michael. They sat right next to each other. Sharon said, "I don't know if Ozzy can understand Michael or if Michael can understand Ozzy." But they both say and laughed together. And I think Sharon ended up ordering food for everyone.

OZZY: "I NEED A LITTLE ████ING PRIVACY."

Episode Guide #10:
Dinner with Ozzy

From the looks of the show's season finale, an uneducated viewer might be tempted to think that Ozzy, the king of metal, an icon for a generation of loud-music lovers, has finally sold out and become just another fancy-schmancy Beverly Hills big shot. Although Ozzy is dining formally as he speaks to the camera in this episode (a direction of the producer's, no doubt), it soon becomes clear that the Prince of Darkness is just a regular family man with a little bit more rock and roll in his blood. In "Dinner with Ozzy," the unlikely luminary reminisces and philosophizes while real-life moments are interspersed throughout Ozzy's narration.

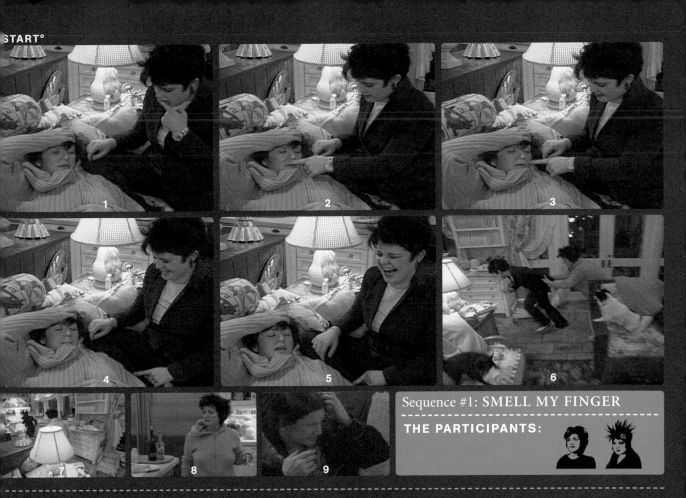

Sequence #1: SMELL MY FINGER
- -
THE PARTICIPANTS:

Ozzy begins his meal by offering his take on life: "Thinking about life, by the time you get old enough to understand what it's all about, you die." Of course, the man of the moment is still alive and kicking and appears to understand a whole lot more than he's given credit for by his family. Ozzy talks about his roots as a child born to working-class parents in Birmingham, England. A poor boy from a small suburb, John Michael Osbourne (Ozzy's birth name) would never have imagined that, as an adult, his life would play itself out in such riches and revelry.

For example, when a stray cat somehow gets into the Osbourne house, the entire family has a field day trying to catch the untamed animal. Ozzy tries to get it down from behind a large antique mirror, while the rest of the crew laughs, screams, and directs Dad.

Then we're back to dining with Ozzy (who now cleanses his palate with a little fruity sorbet before the main course). He delves into what is, perhaps, the most significant aspect of his life, other than his music: his family. As if it hasn't been made clear in the nine preceding episodes, Ozzy informs us that "Sharon is the leader" of the family. He also shares his philosophy about being a parent: "Be rigorously honest."

Examples of Ozzy's forthright ways abound. When Ozzy and Sharon are snogging (British for "kissing") in Jack's room, Jack demands that either they stop or they leave his room. Retorts Ozzy, "Its natural!" Yeah, Jack, how do you think you got here? In another sequence, Kelly and Ozzy peel potatoes together in the kitchen. Ozzy recalls that he learned to skin spuds when he was in jail (for stealing). Clearly, Ozzy is not the average father, and he not only knows this, he is proud of it. After all, how many dads can say they have traveled the world with their tots?

Next, Ozzy talks about having attention deficit disorder. He doesn't have to say very much to get his point across—a montage that pretty much says it all follows. The black-haired bad boy then admits that he was much more out of control as a boy than his own son is. And as much as Jack and Kelly bug the #$&* out of him, he understands that siblings fight.

OZZY TO SHARON: "I LOVE YOU, NOW OFF."

That's just what they do, as made evident by scenes of Jack and Kelly arguing, slapping each other, and just being reckless, unapologetic teens.

At least, Ozzy proudly comments, he can provide his kids with a proper education. But the rocker's sentiment is undermined when the producers cut to Jack's sleeping in on a school day, after being out till two A.M. Ozzy assumes his role as authoritarian and immediately goes up to Jack's room and tells him to "go to school, *now!*" Even Kelly realizes the extent of her parents' domestic abilities. All she wants is for Sharon to cook her something to eat "like a real mom" would. Sure, the Osbourne family's values may differ slightly from your average Beverly Hills family's, but it's hard to envision a clan as fun-loving as the Osbourne crew.

Ozzy then sweetly shares how it was Sharon's laugh that first attracted him to her. He just wishes she'd pay a little more attention to him. (Isn't that all she does?) Ozzy complains of feeling "invisible" and points to his Birmingham accent and tendency to stammer as a reason why people often disregard him.

In a classic montage, Ozzy is seen and heard stuttering and stammering his way through most conversations. If he could be anyone for a day, he says he'd choose to be Paul McCartney. And though he realizes that he's not the most together guy, he realizes that things could be a whole lot worse. "I could be Sting."

Finally, Ozzy gets the recognition he so desperately wants when he is honored with a star on the Hollywood Walk of Fame. And yet, back at the dinner table, Ozzy insists that he is just "a real guy with real feelings."

BEST LINES

† **Ozzy:** "When I discovered music, I was off and running. . . . I always wanted my parents to be proud of me, so I never did anything worth a #$&* in school. I'm incredibly dyslexic. And I . . . um . . . um . . . um . . . My con . . . my concentration span is very . . . short. What do they call that? Whatever. What? What's going on now? Who? What? Who's this? What? Osbourne. Osbourne. Who? What was this? What, who, when? Uh, uh, major attention deficit disorder.

† **Jack:** I was the one behind the [paint pellet] gun, all right. . . . Now, why do you still hold a grudge from . . .
Kelly: Because you shot me!
Jack: From six years ago? And you still get angry when we talk about it, Kelly.
Kelly: Because you #$&*ing shot me!

† **Ozzy:** Kelly is just, Kelly . . .

† **Ozzy to Sharon:** I love you, now #$&* off.

HIGHLIGHTS

† Sharon gives Ozzy a Cool Mint oral care strip (the kind you put on your tongue and it dissolves). Ozzy had never seen them before when Sharon offers it to him. "What is it? Cyanide?" Oz asks. Sharon tells him it's a new kind of gum. "It's a stamp," insists Ozzy. And after he puts it in his mouth, he tells Sharon how he really feels: "It's crap. It disappears . . . it's not gum. You lied to me!"

† Kelly discusses all things taboo with her mom, which leads Sharon to conclude, "We should have named you Vagina Osbourne!"

BAD WORD BOX SCORE

30 4 10 6 3

JT: We wrapped on a Saturday, and the next Friday we had a party with their whole family and the crew. It was at the Lounge, a nightclub on Sunset and Vine. We took over the place and aired the first episode and then the outtakes. It included a scene of Jack chasing me around the front yard, trying to beat me up. Things like that. It was a crazy night.

MELINDA: When the crew left, we were glad to have our place back. But during the outtakes reel at the wrap party, Jack leaned over to me and said, "Melinda, we had fun doing that, didn't we?" I said yeah, and all of a sudden, I felt really sad they were going to be gone.

JASON: I'm in Detroit. Four weird biker dudes come up to me and go, "Hey, you're that weird skateboarder dude from *The Osbournes*." Suddenly, I'm in a bar by myself with four biker dudes who think I'm a bit of a softy. That sucked. But I got out of that situation okay. Then a short time later I was in a Santa Monica bar. I order a drink, and a woman comes out of nowhere and screams, "Don't serve him! He's the guy from *The Osbournes*. He won't pay his bill." Luckily, the bartender at the establishment is a friend of mine, and he didn't listen to her.

TAMAR: Everywhere I went, people would mimic Ozzy by saying, "See ya, Tamra." I'd go into a store, and they'd say, "See ya, Tamra." It was all great—except my name is Tamar.

JACK: It's been weird being recognized. I don't love it, but I don't hate it.

JASON: Now, there's a shinier side of the coin. I'm in Indianapolis at a fine place called Sheik's—a strip club. I'm eating steaks, drinking whiskey, smoking cigarettes. Having a great time. Everything's fantastic. I've got a bunch of dirty skateboarders with me. We all make a lot of money. We're all

just getting wild. I've only been there a half hour when this girl sits down next to me. She's a really tall, really beautiful, really exotic-looking white chick. I haven't had sex with a white girl in ages. But she's just off the charts. She sits down and says, "You look like that dude from *The Osbournes*." And I was like, "That could be." She says, "Were you on *The Osbournes?*" I say yeah, and she says, "Oh my God, what are you doing in town?" We talk, the vibe is going, and soon I ask, "What time do you get off?" She said, "Anytime you want . . ."

MELINDA: If the second season is anything like the first one, it'll be fantastic.

SHARON: It's hard for me to say what worked and what didn't, but I'm sorry about a lot of the swearing. You don't realize how much you swear when you're doing it. It comes so naturally after a while. And I'm sorry about that. But it is what it is. Just like we are who we are. I can't change that. I can try to do better—that's it.

JACK: Lola isn't #$&*ing everyplace. She's not like that anymore. She's mellow, well-trained. She's still a little bit hyper, but she's better, and I have pretty much taken her back.

KELLY: Next time, I want to know the full deal about everything. The problem is, no one ever tells me anything. It feels like I've had my life signed away, and no one informed me about it. If we ever did it again, we'd have to have certain days off, no would have to mean no, telephone conversations couldn't be recorded. I don't want people knowing that much about my life.

JACK: I've spent the summer surfing, working out, and being with my mom. Ordinary stuff. I like tattoos. I'm hoping to get one soon. Maybe my family shield on my chest, and then my whole back done, though I'm trying to figure out what.

OZZY: "I'M NOT PICKING UP ANOTHER TURD. I'M A ████ING ROCK STAR."

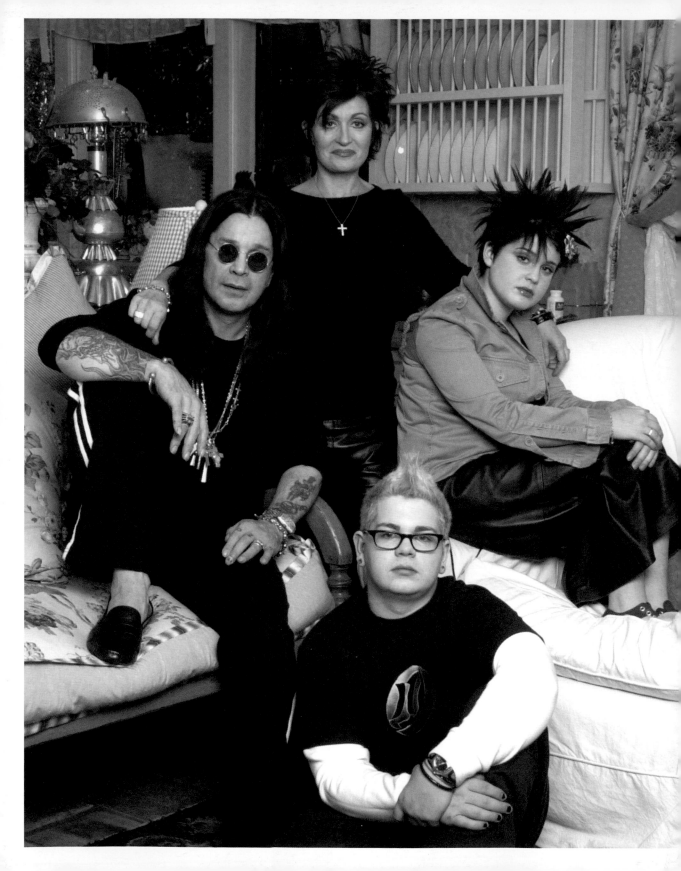